IMAGES
of America

WOBURN

IMAGES
of America

WOBURN

Kathleen M. O'Doherty

ARCADIA

First published 2000

Published by Arcadia Publishing,
an imprint of Tempus Publishing, Inc.
2 Cumberland Street
Charleston, SC 29401

Printed in Great Britain.

Library of Congress Catalog Card Number: 99-069015

For all general information contact Arcadia Publishing at:
Telephone 843-853-2070
Fax 843-853-0044
E-Mail sales@arcadiapublishing.com

For customer service and orders:
Toll-Free 1-888-313-2665

Visit us on the internet at http://www.arcadiaimages.com

*Dedicated to the librarians
and staff of the Woburn Public
Library, past and present.*

CONTENTS

ACKNOWLEDGMENTS

The photographs in this book are from the Thomas J. Glennon Archives at the Woburn Public Library. I would like to thank the Trustees of the Woburn Public Library without whose support this project would not have been possible: Lawrence Byron Jr., Elizabeth Doherty, Nancy Halliday, Dorothy Keller, Judith Kelley, Robert Maguire, Kathryn Martin, Janet Rabbitt, and Loretta Schuck.

I would also like to acknowledge that this work owes a great deal to the generosity of those who, over the years, donated photographs and/or historical materials to the Woburn Public Library. Without these photographers, artists, and historians of the local scene, this work would not have been possible. In particular, the Dexter Bulfinch Johnson Collection, recently given to the library by the Mr. Johnson's family, was an invaluable resource.

I would like to thank the following individuals for their assistance: Sue Ellen Holland, Joshua Estes, Colin Michaud, and Thomas Michaud. Finally, I thank my husband, Shaheen Mozaffar, for his love, support, and encouragement.

INTRODUCTION

In 1640, seven men from Charlestown, Massachusetts, were sent out to find a suitable location for a new village. After much deliberation, present-day Woburn, Massachusetts, was chosen as the site. Charlestown Village, as it was to be called, grew quickly and within two years a pastor and church were a part of the community. Plans were soon under way to create a distinct town. The Massachusetts General Court met in session in the fall of 1642 and the Town of Woburn was incorporated on October 7, 1642. The act of incorporation read: "Charlestowne Village is called Wooborne." Originally, the new community also included all or parts of present-day Winchester, Burlington, and Wilmington.

In the early days, farming was the chief occupation of the settlers. Agriculture continued to predominate until the end of the 18th century when shoemaking started to come into its own. The shoe industry emerged because leather was easily available in Woburn. As early as the middle of the 17th century, there was a tannery in Woburn located in the Central Square section of the town. It was operated by John and Francis Wyman, two of the original signers of the Town Orders. Town records reveal that, during King Philip's War, Woburn's taxes were partly paid in shoes.

The Middlesex Canal was the catalyst for Woburn's industrial growth in the early days of the 19th century. Its 31 miles of waterways facilitated the transport of goods to Boston. Loammi Baldwin of Woburn was the chief engineer in its construction. The canal, however, soon gave way to the railroad, which also contributed to the rise of Woburn as a major manufacturing town. The shoemaking industry declined as the demand for leather for other purposes increased—especially at the time of the Civil War. Woburn became a "leather town" whose economic prosperity rose and fell with the state of the business.

Agriculture and shoemaking were not the only activities that absorbed the lives of Woburn's people. Woburn and its people have made many contributions to our nation's history over the course of the last 350 years. The first death at the Battle of Lexington and Concord is said to have be that of a Woburn man, Asahel Porter. The first enemy soldier captured that day was by another Woburn man, Sylvanus Wood. In the Civil War and the Spanish-American War, Woburn gave generously of its people. The Father of American Civil Engineering was Woburn's Loammi Baldwin II, son of the chief engineer of the Middlesex Canal. Woburn-born scientist and inventor Benjamin Thompson, Count Rumford, while a relative unknown in his own country, was and is highly regarded in Europe. He has been called one of the greatest minds this country has ever produced. Unfortunately, his Loyalist leanings during the American

Revolution have consigned him to obscurity in his own homeland. It was in Woburn that Charles Goodyear discovered the process of vulcanizing rubber. Adm. Charles Wellman Parks, an 1879 graduate of Woburn High School, is credited with the design of the naval base at Pearl Harbor.

Others in Woburn who may not have achieved national notoriety but who nonetheless had an impact on their community are also chronicled in these pages. The Winn family of Woburn left an incredible legacy in the present Woburn Public Library. Jonathan Bowers Winn was instrumental in starting the first public library in Woburn in 1855. His son Charles Bowers Winn secured his father's standing in Woburn history by leaving the bulk of his estate to build the current library building and by decreeing that it should be an ornament to the town. His wishes were granted when the Woburn Library Committee selected the services of architect Henry Hobson Richardson to design the new building. Opened in May 1879, Richardson's first public library was designated a National Historic Landmark in 1987. The building's first librarians also served their community in various ways. George M. Champney, the first librarian of the new facility, who later died on its doorstep, collected historical materials and indexed the *History of Woburn* by Samuel Sewall, published in 1868. William Cutter, the second librarian, compiled genealogical works and wrote many articles on the history of Woburn. Another person who made an impact on the local scene in the 19th century was Edward F. Johnson. In 1889, responding to increases in population, Woburn was incorporated as a city. Its first elected mayor was Edward F. Johnson, a descendant of the original Edward Johnson who helped found the city and who was known as the Father of Woburn.

This book focuses on Woburn from its small, agrarian beginnings to its development as an industrialized city on the brink of the 20th century. This is Woburn in history, at war, at work, and at play. The documents and photographs seen here are from the Glennon Archives of the Woburn Public Library. Their very existence is testament to the perspicacity of our forefathers. Their pride in who they were and what Woburn meant to them is evident in their desire to preserve this past for future generations.

One

WOBURN IN HISTORY

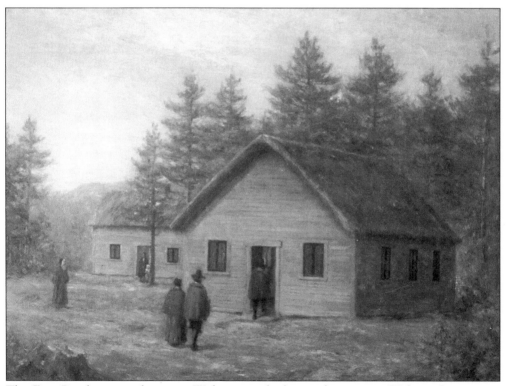

The First Parish meetinghouse in Woburn was built on what is now Woburn Common c. 1641–42. Albert Thompson's painting (from the collection of the Woburn Public Library) depicts the building, which stood until 1672. The Reverend Thomas Carter was the first pastor of the new church.

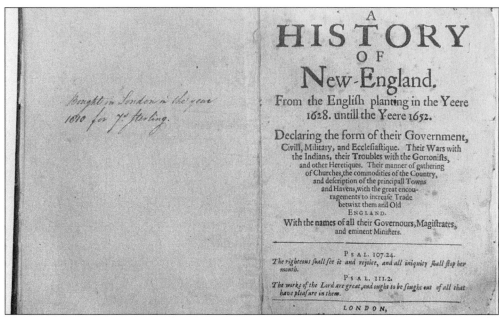

A HISTORY
OF
New-England.

From the English planting in the Yeere
1628. untill the Yeere 1652.

Declaring the form of their Government,
Civill, Military, and Ecclesiastique. Their Wars with
the Indians, their Troubles with the Gortonists,
and other Heretiques. Their manner of gathering
of Churches, the commodities of the Country,
and description of the principall Towns
and Havens, with the great encou-
ragements to increase Trade
betwixt them and Old
ENGLAND.

With the names of all their Governours, Magistrates,
and eminent Ministers.

PSAL. 107.24.
*The righteous shall see it and rejoice, and all iniquity shall stop her
mouth.*
PSAL. 111.2.
*The works of the Lord are great, and ought to be sought out of all that
have pleasure in them.*

LONDON,

The Father of Woburn, Capt. Edward Johnson (1598–1672), was the author of the first printed history of the Massachusetts Colony. His *A History of New-England*, sometimes also called *Wonder-working Providence of Zion's Saviour in New England*, was published in London in 1654.

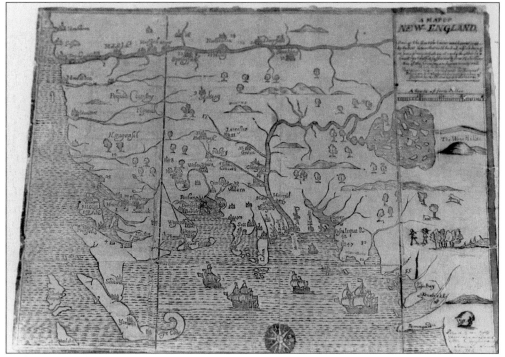

Hubbard's *Map of New-England, 1676* was one of the first engraved maps in this country. It was drawn to show the towns attacked by Indians in King Philip's War (1675–76). Woburn, located in the center of the map, suffered three casualties during the conflict. A mother and two children from the Richardson family were killed in 1676.

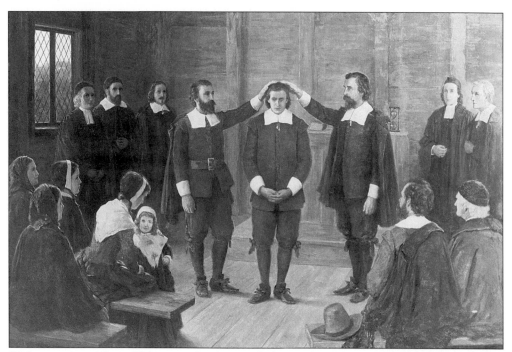

Woburn artist Albert Thompson (1853–1906) depicted a historic scene in early Woburn history: *The Ordination of Thomas Carter, December 6, 1642*. Thomas Carter was the first pastor of Woburn's new church.

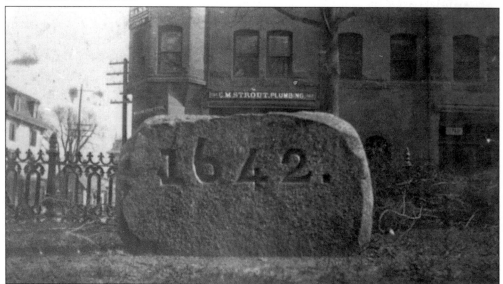

The Horse Block has been traced back to at least the year 1680 as being in front of the first meetinghouse, which was built around 1642. It was used by those arriving on horseback for dismounting. In 1864, it was removed from the foundation of the fifth meetinghouse occupied by the First Congregational Church, which had been sold to the Unitarian parish. It was then placed in its present location—the yard of the First Congregational Church on Main Street. Ephraim Cutter, who supervised the removal of the block, had the date 1642 inscribed in the stone.

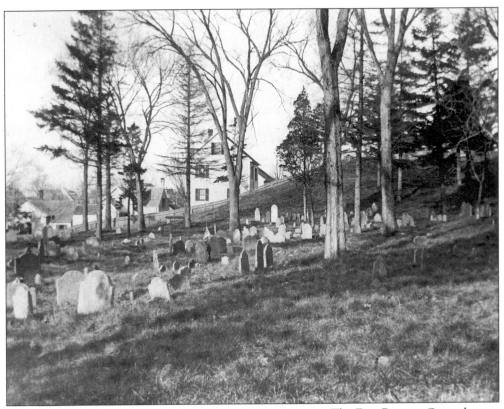

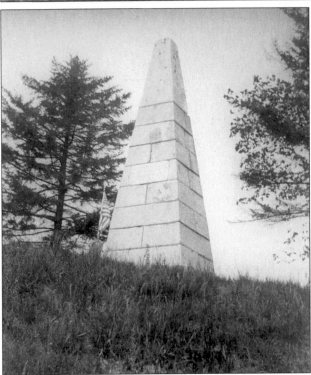

The First Burying Ground on Park Street, just off Woburn Center, opened in 1642. The earliest markers of wood have long since vanished. The first four ministers of the First Parish are buried here: Thomas Carter, 1684; Jabex Fox, 1703; Edward Jackson, 1754; and John Fox, 1756. Fifteen Revolutionary War soldiers are also buried in this yard. The parish closed the cemetery in 1793 but later allowed the interment of a few others including Loammi Baldwin, who died in 1807.

The Baldwin Obelisk stands on a hill in the First Burying Ground. Although the cemetery closed in 1793, Loammi Baldwin's heirs received permission from the Town in 1810 to build a tomb.

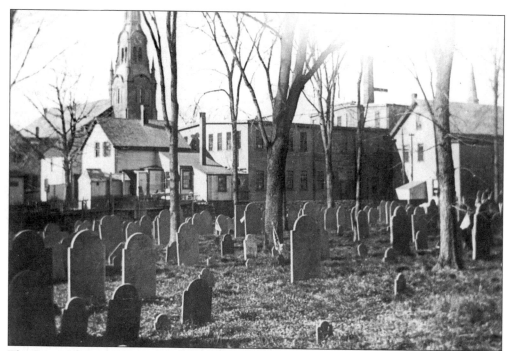

The Second Burying Ground was established in 1794 when the parish voted to purchase about an acre of land on present-day Montvale Avenue. In 1824, the parish sold the burying ground to the Town for $162.50. Fifty-one Revolutionary War soldiers were buried here. In 1845, Woodbrook Cemetery opened on Salem Street and the Second Burying Ground was closed. The Second Burying Ground is located behind the Peterson School on Montvale Avenue.

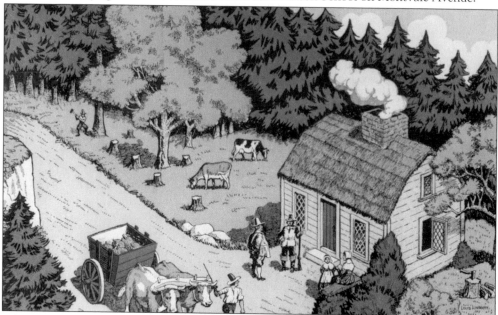

John Mousall, one of the founders of the town, built the first dwelling house in the present-day limits of Woburn in 1640. No longer in existence, the house was located on Hilly Way, now Montvale Avenue, near the Second Burial Ground. (Louis Linscott print.)

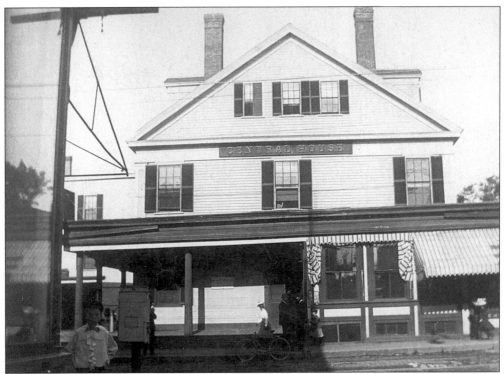

This was the site of the Marshall Fowle Tavern, which was built in 1691 and torn down in 1840 to be replaced by the Central House, seen here. In 1775, the Woburn Minutemen were formed here and met once each week to instruct themselves in the handling of their weapons. The tavern was located on Main Street opposite Everett Street.

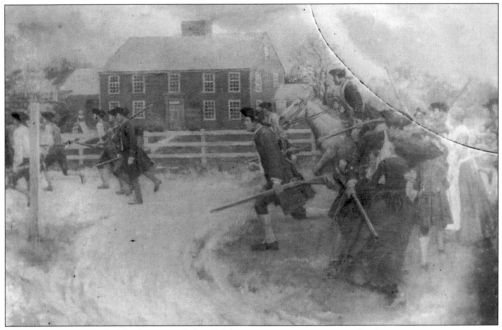

Pictured is an artist's conception of the Woburn troops starting out for Lexington.

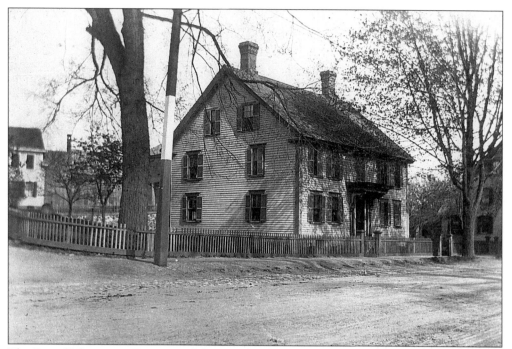

The Daniel Thompson House is still located on Clinton Street off Main Street. Thompson left from this house to take part in the Battle of Concord on April 19, 1775. Slain that day, his remains were interred in the First Burial Ground on Park Street on April 21, 1775.

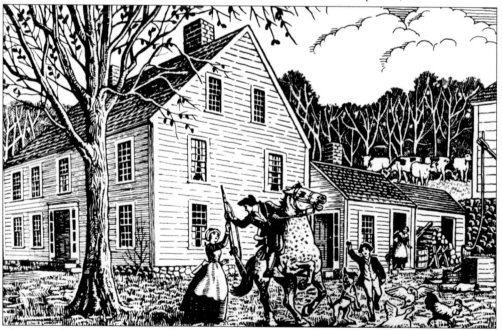

This print depicts the scene at the Daniel Thompson House on the morning of April 19, 1775, as the 40-year-old Thompson prepares to leave on his ill-fated journey. Early in the afternoon, during the retreat of the British from Concord, Thompson was shot dead in Lincoln by a grenadier. (Louis Linscott print.)

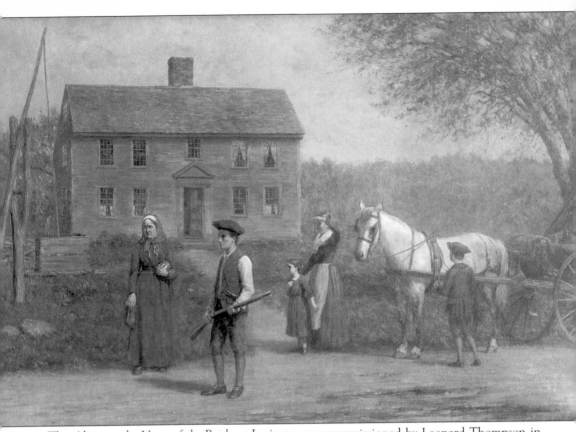

The *Alarm at the News of the Battle at Lexington* was commissioned by Leonard Thompson in 1898 and given to the Woburn Public Library the following year. Painter Albert Thompson (1853–1906) depicts an historic episode in Woburn history. The scene is the house of Capt. Jesse Wyman on Lowell Street and shows the family as they react to the news of April 19, 1775.

Pictured is the Old South Road, which runs parallel to Russell Street. It was over this road that some 180 men from Woburn hurried to the battles of Lexington and Concord. Sylvanus Wood, along with other citizens of Woburn, received word of the British march on Lexington long before daybreak, walked to Lexington, was mustered into Captain Parker's company, and was there when the British fired. Wood later made the first capture of an enemy soldier.

Alva Wood on the spot where his grandfather Sylvanus Wood captured the first enemy soldier of the Revolutionary War on April 19, 1775. Sylvanus Wood was later granted a pension by the U.S. government in recognition of his act.

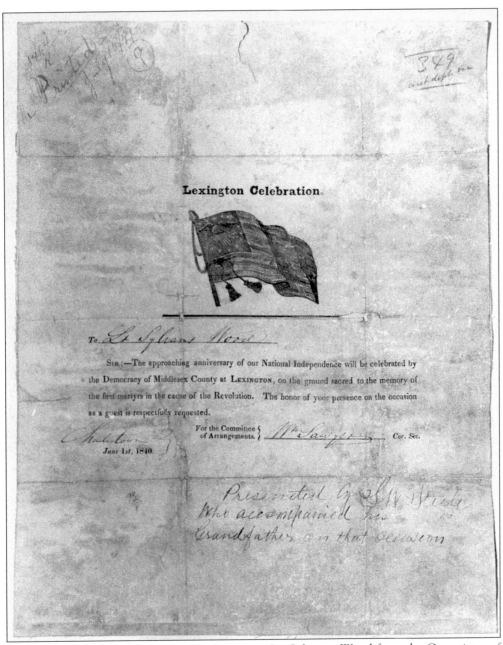

This photograph shows the original invitation to Lt. Sylvanus Wood from the Committee of Arrangements for the Lexington Celebration in 1840. Alva Wood accompanied his grandfather on the occasion and later donated the invitation to the Woburn Public Library. Sylvanus Wood lived to be 90 years old.

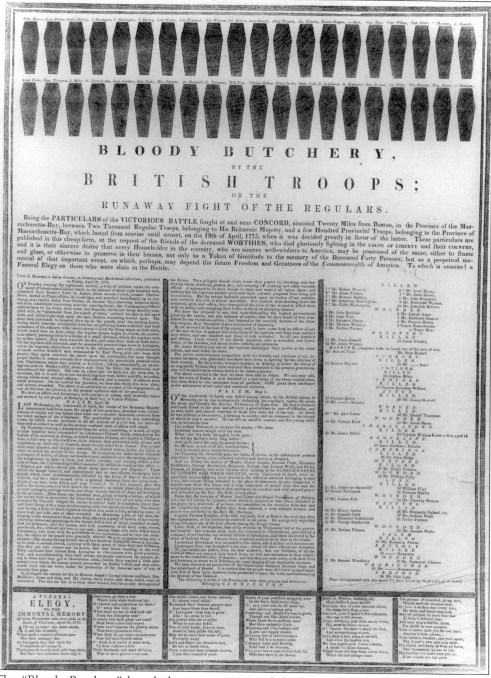

The "Bloody Butchery" broadside is an account of the battles of Lexington and Concord, printed shortly after April 19, 1775. The first two coffins in the second row represent the two Woburn men who fell that day: Asahel Porter and Daniel Thompson.

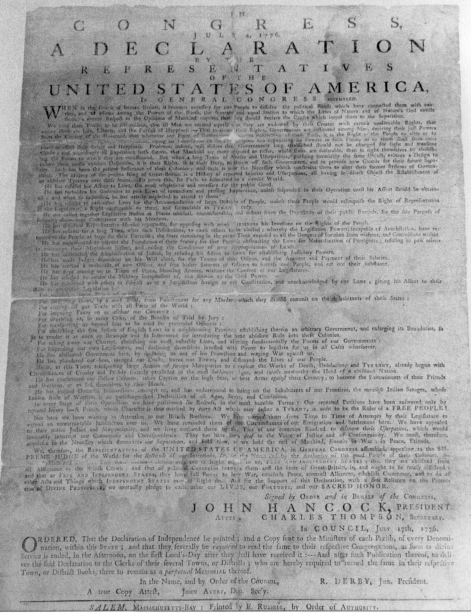

Copies of the Declaration of Independence were printed throughout the 13 colonies for public consumption. They were sent to the various villages and parishes, where they were read from the pulpit and posted at the local tavern. Woburn's copy, printed in Salem by Ezekial Russell, was preserved and eventually handed over to the library by Nathan Wyman, town clerk.

Two

HOMES AND HISTORIC SITES

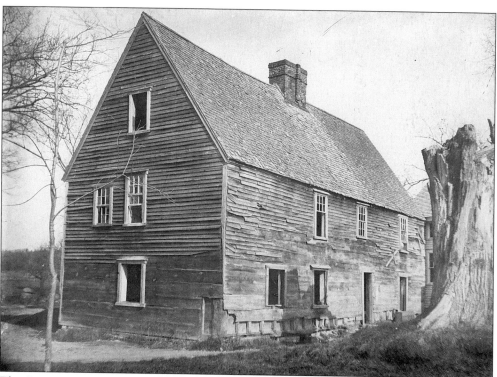

The Benjamin Simonds-Jesse Cutler House was built in 1698 on the south side of Bedford Road. At one time, the Episcopal society held services here. The building was destroyed in 1904 or 1905, but a diamond-paned window was saved and is now in the Woburn Public Library's museum collection.

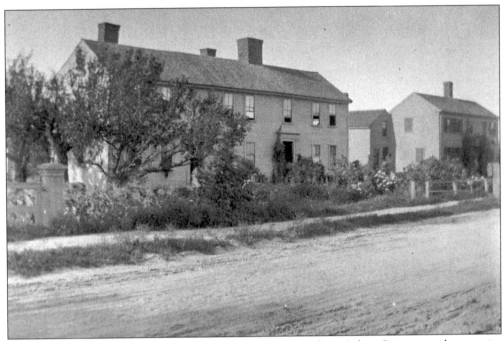

The Running Spring House, pictured in 1898, was located on Salem Street, nearly opposite Wood Street. Built c. 1798, it was torn down in the 1940s.

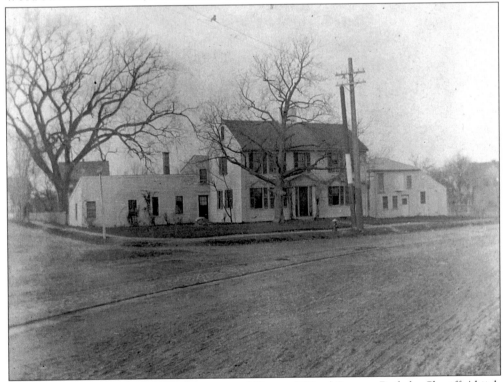

The Moses Winn House was on the corner of Elm and Ward Streets. Built by Sheriff Abijah Thompson in 1760, it was torn down in 1910.

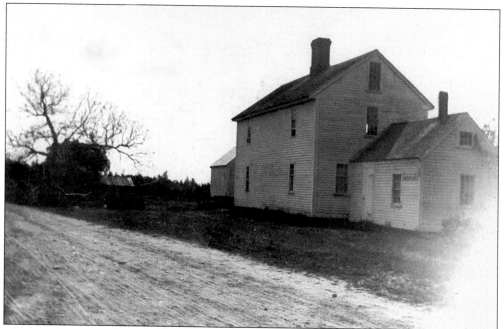

The Ames House, built c. 1730, was on New Boston Street. The house was owned by the Deacon Samuel Eames before 1775, by Samuel E. and Elijah Wyman in 1798, and eventually by Jacob Ames in 1896. It was demolished in 1953.

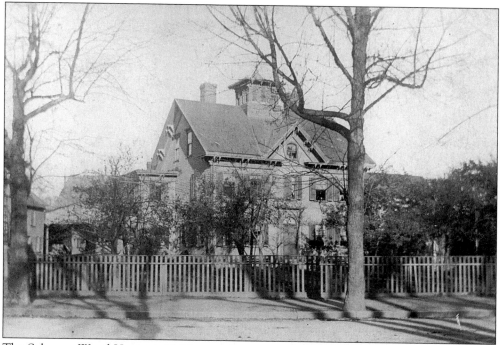

The Sylvanus Wood House at 23 Pleasant Street was the home of the late Charles H. Taylor. The first parsonage in Woburn, built in 1642, was part of this house, which was torn down to make way for a filling station c. 1923. The house, which had 12 outside doors, was located next to the Woburn Public Library.

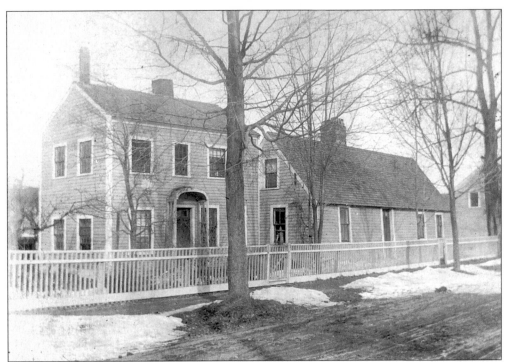

The Old Storage House on Lowell Street was so called because Bill Young, the last driver of the Woburn Stage, lived there as early as 1816, using the stable for the coach and horses. The house itself may be much older, as it is believed to have been moved to this spot during the American Revolution. Tradition has it that it may have been the oldest cider mill in New England.

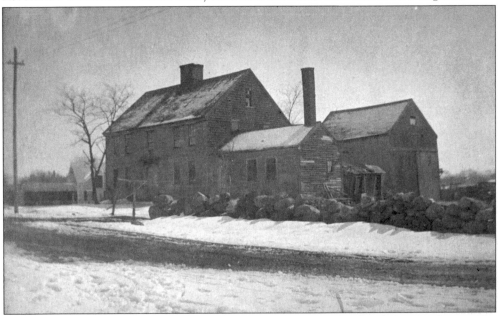

Built in 1759, the Benjamin Wyman House stood on the south side of Wyman Street. The Wymans operated a tannery before 1675 near the junction of present Main and Wyman Streets at Central Square. This house was destroyed by fire on July 5, 1900.

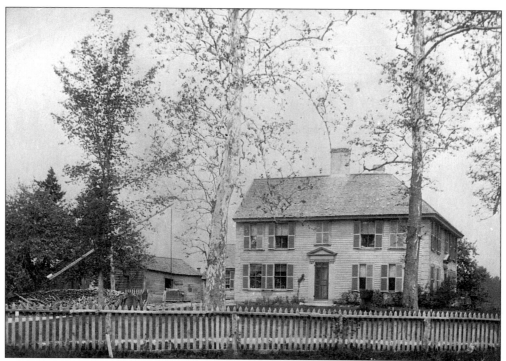

Burlington was part of Woburn until 1799. The Sewall House was built in Burlington in the early 1700s. The house was a refuge for John Hancock, Samuel Adams, and Dorothy Quincy during the Battle of Lexington and Concord, April 19, 1775.

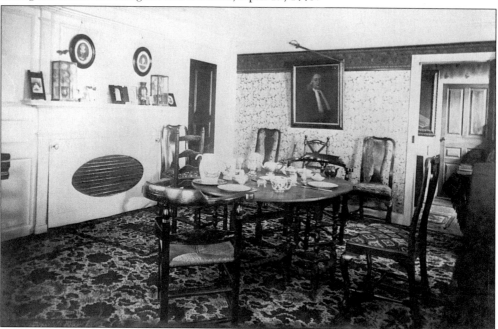

Pictured here is the dining room of the Sewall House. The house was bought by the Reverend Thomas Jones in 1751 and was owned by his descendants for 146 years. It was destroyed by fire in 1897.

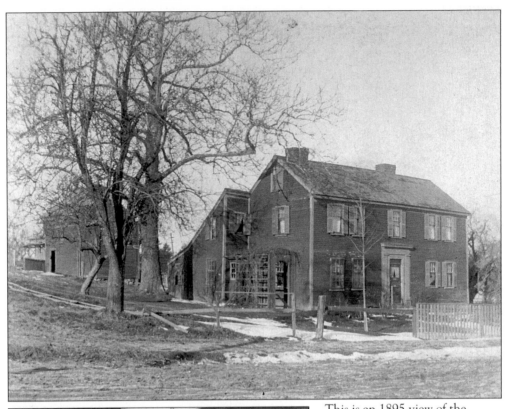

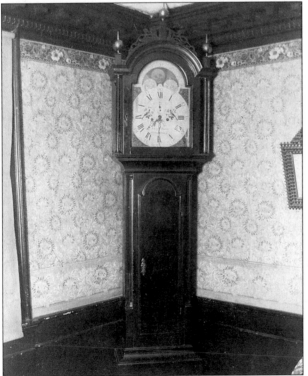

This is an 1895 view of the Bartholomew Richardson House on the corner of Bow and Salem Streets. It was located here *c.* 1760, when Bartholomew Richardson married Sarah Converse and was given part of the Converse House, which he moved to this spot. Later additions were made to the house. The original Converse House on Salem Street was torn down in 1876.

At the time this photograph was taken in 1897, this clock had stood in one spot for 100 years in the Bartholomew Richardson House. It was made for Bartholomew Richardson and delivered to him on March 3, 1797. The price was $50.17.

The Abel Winn House is on the corner of Winn and Wyman Streets in Burlington. It was built in 1734 on the exact site of its predecessor, the log cabin of Edward Winn. Edward Winn's cabin was built in 1640, and it was there that the first child of the town, Increase Winn, was born on December 5, 1641. The later house was kept as a tavern by Lt. Joseph Winn during the Revolution. It is said that in 1789, Gen. George Washington stopped here, warmed his shins, and wet his whistle.

The Deacon Joseph G. Pollard House, built in 1845 on Green Street, was the first house in the Highland district.

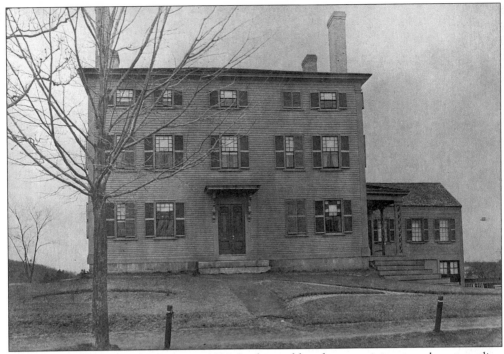

Lt. Jonathan Tidd built this house in 1809. It changed hands many times over the succeeding years but eventually was purchased by Tidd's grandson William in 1889. In April 1889, the grandson gave the property to the Woburn Home for Aged Women. In 1953, the name was changed to the Tidd Home.

Pictured is Charlotte Pamelin Wyman, daughter of William and Eunice (Walker) Wyman, who was born in Burlington in 1815. She became a resident of the Home for Aged Women on July 16, 1892. She died June 22, 1900, at the age of 85.

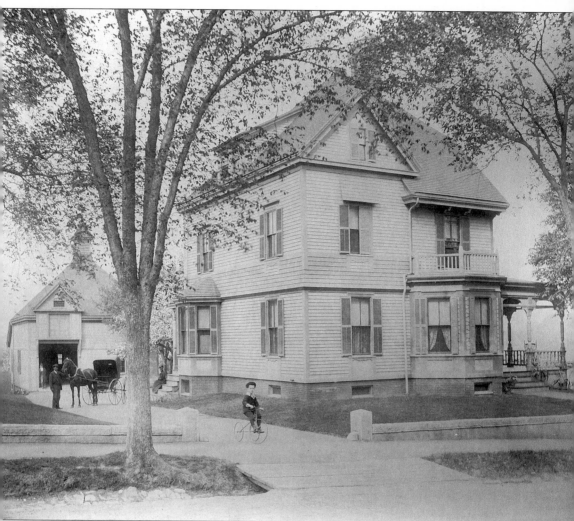

Pictured is the house of Charles A. and Emily Tidd Jones at 11 Warren Avenue. The child on the bicycle may be their son Arthur V. Jones. Years later, on September 20, 1924, Arthur Jones donated a collection of books and a drum to the Woburn Public Library in memory of his parents. The drum has an interesting history: it is said to have been the same drum that was used in the painting *The Spirit of '76*, by Archibald Willard. The drum is still preserved in the library and is occasionally placed on exhibit.

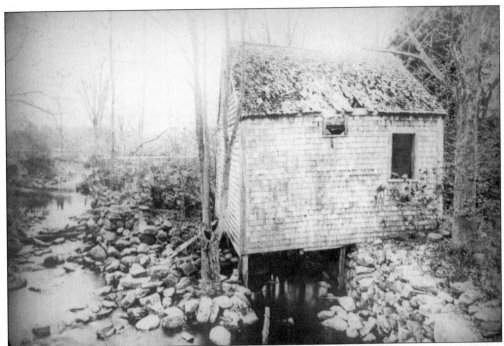

Kendall's Mill was built near the junction of Cambridge and Russell Streets soon after 1700 by Samuel Kendall. By the year 1800, it was one of seven gristmills in Woburn. It continued in use until *c.* 1900 and was demolished in 1902.

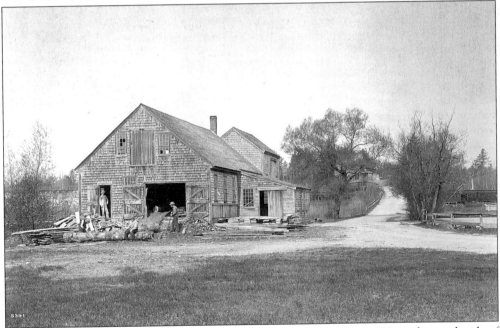

This is an 1891 view of Richardson's Mill. It was built as a sawmill in 1843 on the south side of Mishawum Road on the banks of the Aberjona River. A gristmill was added to the rear in 1856. In the doorway at the left is Alfred T. Carter. Sitting on the log is Jacob Ames, and stooping over is Ralph Fish. The mill was destroyed by fire on December 18, 1895.

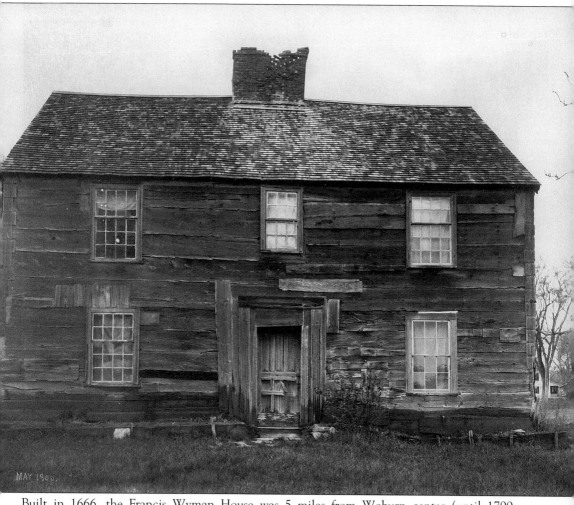

MAY 1900.

Built in 1666, the Francis Wyman House was 5 miles from Woburn center (until 1799, Burlington was a part of Woburn). It was used as a garrison house against the Indians in 1675. From 1676 to 1679, it was leased by Francis Wyman to Edward Farmer of Billerica. During a lawsuit between them, it was testified that the Indian peril was so great that it was difficult to get a tenant to live at such a distance from the town. The building is now owned by the Francis Wyman Association.

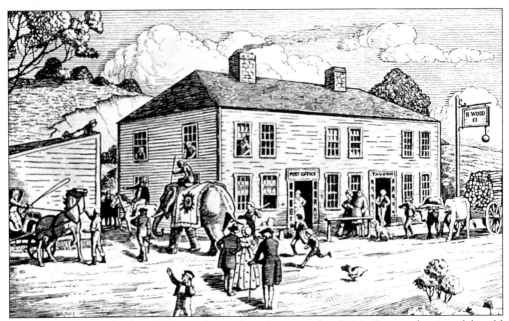

The Wood Tavern, built *c.* 1798, was located on the east side of Main Street, the site of the old Woolworth Block. Ben Wood was the proprietor. The first-story front was used for stores, printing offices, and entrance to the hotel. A gilt ball marked "B. Wood" hung outside which meant, as he was wont to say, that "Ben Wood is on the earth." Just north of this location was Wood's barn where in 1817, the first elephant in Woburn was shown.

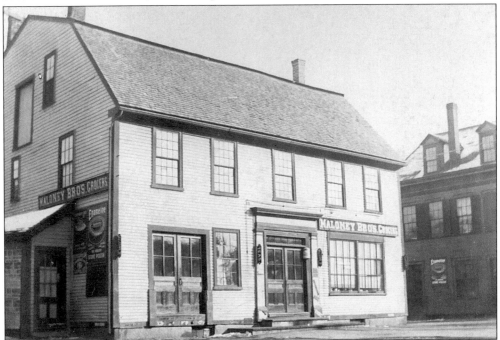

This is the site at Main and Salem Streets of the Flagg Tavern. Built *c.* 1730, it was first the house of Maj. John Fowle. It was operated as a tavern in 1827 and later became Maloney Brothers Grocers. The building was removed in 1929. A gas station now occupies the site.

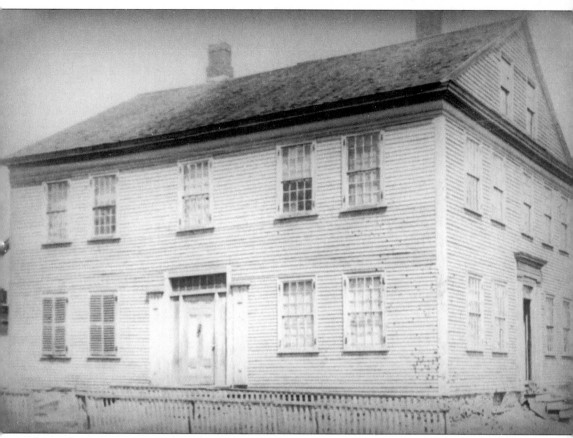

The Mishawum House stood on the corner of Main Street and Mishawum Road. In 1785, John Fowle of Woburn sold the property to Ichabod "Bud" Parker for 155 pounds. Parker opened a public house, which also served as a stagecoach stop. A stage that ran daily between Boston and Amherst, New Hampshire, stopped here to change horses. Henry Clay was entertained at the public house in 1830. In 1797, Parker was named Woburn's first U.S. postmaster. A corner of his barroom served as a post office. His desk and mail sorter are preserved in the Woburn Public Library. The tavern's business dwindled with the coming of the railroad. The tavern changed hands many times and in the late 1880s, it was moved to Kilby Street.

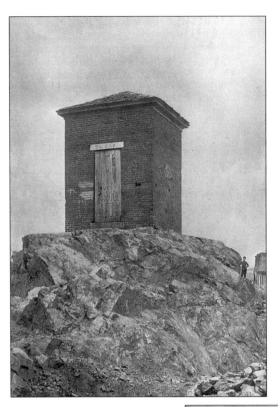

The Old Powder House was built on Bell Hill in 1812. The hill was so named after a bell was placed there to summon people to church and town meetings in the early years of the settlement. Because war with England was imminent, each town was required by law to store powder, muskets, musket balls, and camp kettles. Located off Mann's Court, the Old Powder House was demolished in 1898.

The Statement of Expenses of the Town of Woburn for 1812–1813 was the first printed town report. It includes the expenses involved in the construction and stocking of the Old Powder House, or magazine as it is called. Benjamin F. Baldwin was paid $5 for his services as a "committee for building the magazine."

Statement of Expenses.

Of the TOWN of WOBURN, from April 1st, 1812, to April 1st, 1813.

Three

WOBURN PEOPLE

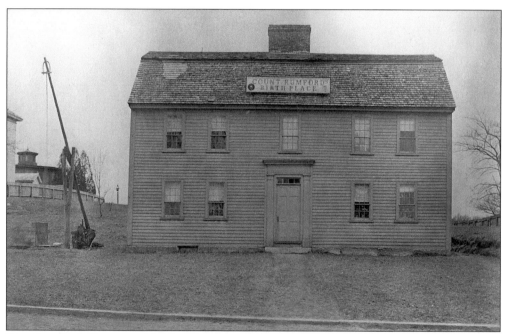

The Rumford House in North Woburn was built in 1714 by Ebenezer Thompson, the grandfather of Count Rumford. Benjamin Thompson, later to be known as Count Rumford, was born in this house in 1753. Located on Elm Street, the building has been designated a National Historic Landmark and is open to visitors.

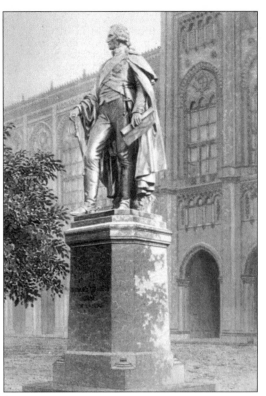

Benjamin Thompson, Count Rumford, was born in Woburn in 1753. The inventor of items such as the drip coffeepot and the kitchen stove, he was unappreciated in his own country because of his Loyalist leanings. He is celebrated in Europe and especially in Munich, where this statue is located. Marshall Tidd of Woburn paid for a replica of this monument and in 1899, it was placed on the front lawn of the Woburn Public Library.

Pictured below is the cradle in which Benjamin Thompson, later Count Rumford, was rocked.

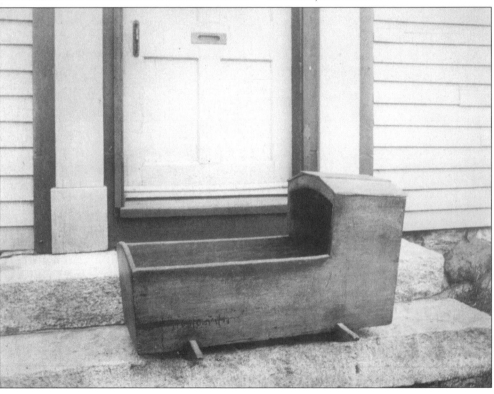

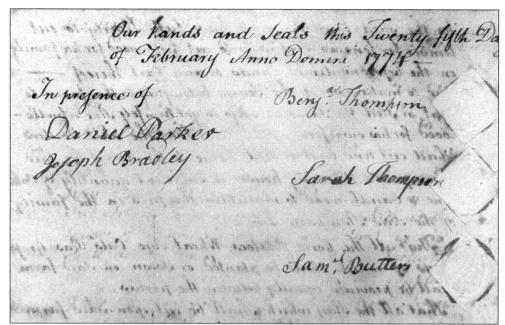

This 1774 lease bears the signature of Benjamin Thompson. This lease was also signed by his wife, Sarah Thompson.

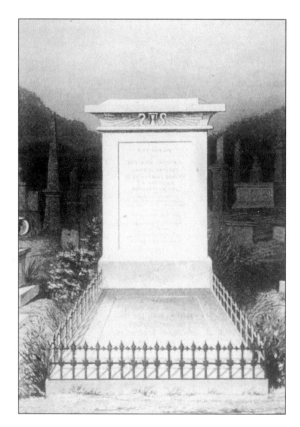

This photograph shows Count Rumford's grave at Auteuil, France. The count died on August 21, 1814. Franklin D. Roosevelt is reported to have said that the three greatest minds America ever produced were Thomas Jefferson, Benjamin Franklin, and Benjamin Thompson, Count Rumford.

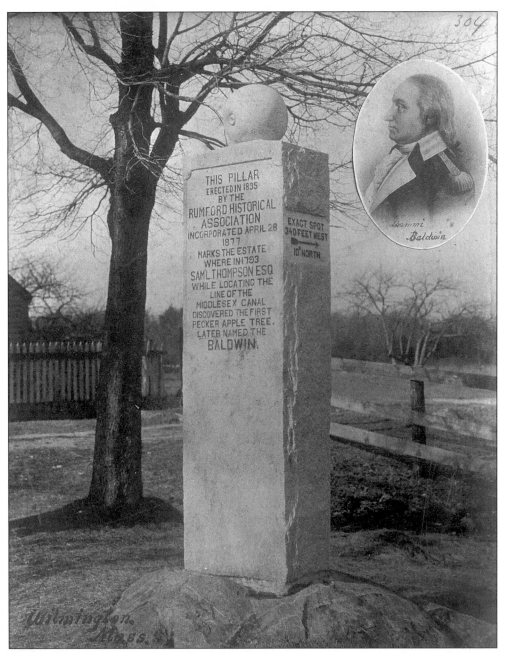

The following text appears on the monument:

THIS PILLAR
ERECTED IN 1895
BY THE
RUMFORD HISTORICAL
ASSOCIATION
INCORPORATED APRIL 28
1877
MARKS THE ESTATE
WHERE IN 1793
SAM.L.THOMPSON ESQ.
WHILE LOCATING THE
LINE OF THE
MIDDLESEX CANAL
DISCOVERED THE FIRST
PECKER APPLE TREE.
LATER NAMED THE
BALDWIN.

EXACT SPOT
340 FEET WEST
10" NORTH

Loammi
Baldwin

Wilmington.
Mass.

The Baldwin Apple Monument, located in Wilmington, was erected in honor of Loammi Baldwin, who was born in Woburn in 1745. Baldwin, pictured in the inset, was engaged in surveying and engineering. He was appointed a lieutenant colonel in the Continental Army and served with Washington's army in its attack on Trenton. He was the chief engineer for the Middlesex Canal, 1793–1803. The strain of apple discovered during the construction of the canal was named for him. Baldwin died in Woburn in 1807.

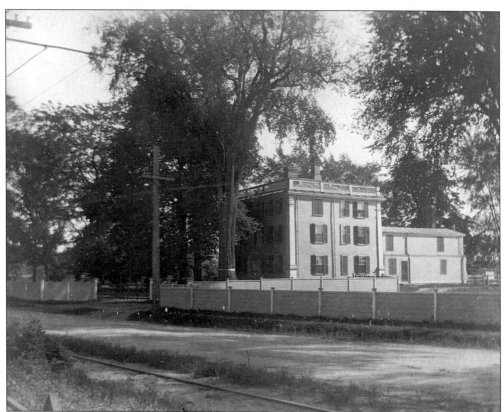

The Baldwin Mansion in North Woburn was built by Henry Baldwin in 1661. Col. Loammi Baldwin was born here in 1745. This view was taken in 1905. Years later the building was moved to Alfred Street, and it is now a restaurant.

Loammi Baldwin II was born in Woburn in 1780. He was a civil engineer and lawyer. He designed and built the dry docks at the navy yards in Charlestown, Massachusetts, and Norfolk, Virginia. Called the Father of American Civil Engineering, he died in Charlestown in 1838. This likeness was sculpted by noted artist Hiram Powers in 1837.

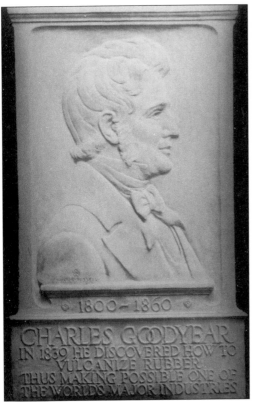

Charles Goodyear (1800–1860) lived and worked in Woburn in the 1830s. For more than five years, his family suffered incredible hardship and poverty while he labored to prove that natural rubber could be a useful product. Although there is some dispute as to exactly where the breakthrough happened, it is agreed that in 1839, Goodyear discovered the process of vulcanizing rubber in Woburn. William R. Cutter, librarian and local historian, reported that the discovery may have taken place in a store at Button End, which was in East Woburn.

William R. Cutter recorded that Charles Goodyear may have boarded for a year with the family of Putnam Emerson in Montvale. During Goodyear's stay at the Emersons, one of his children died and is buried in Woburn. Goodyear later lived in the house at 280 Montvale Avenue, shown below. Many of the neighbors helped feed the Goodyear family during that time. This building has been torn down.

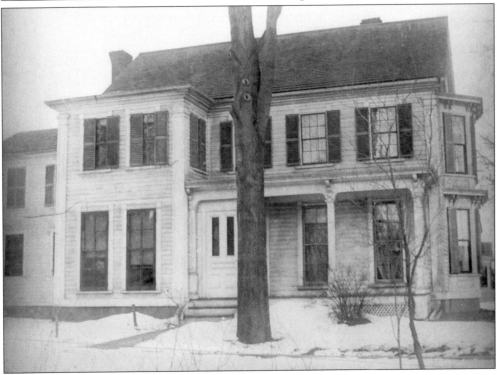

John Cummings (1812–1898) was treasurer at the Massachusetts Institute of Technology. He used his personal fortune to help the school out of financial difficulties. Cummings donated a natural history museum to the Woburn Public Library.

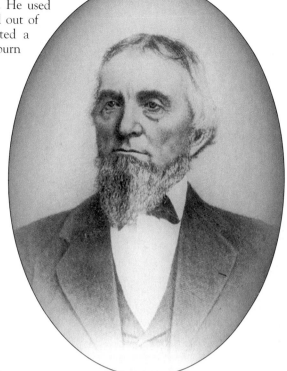

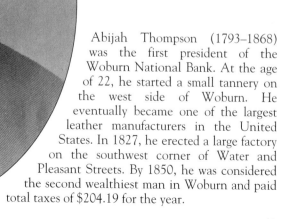

Abijah Thompson (1793–1868) was the first president of the Woburn National Bank. At the age of 22, he started a small tannery on the west side of Woburn. He eventually became one of the largest leather manufacturers in the United States. In 1827, he erected a large factory on the southwest corner of Water and Pleasant Streets. By 1850, he was considered the second wealthiest man in Woburn and paid total taxes of $204.19 for the year.

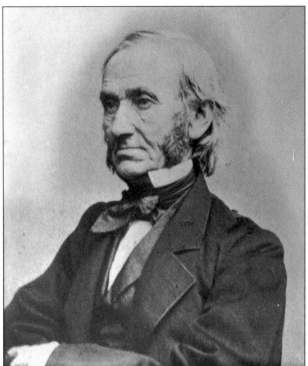

Bowen Buckman (1788–1864) at the age of 12 went to work for Col. John Wade in his store at the corner of present-day Park and Main Streets. Later, Buckman owned the store, and it became a favorite meeting place where the community debated local issues. Buckman became a leader in the community and held various offices. In his will he bequeathed $500 to the town library, thus establishing its first trust fund.

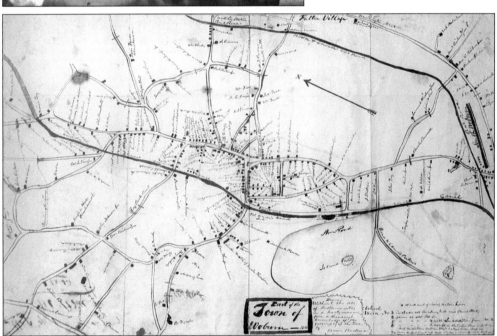

This is a map entitled "Part of the Town of Woburn, 1843." To the right of the title is the note "Drawn without the use of instruments, in a hasty manner, from a thorough knowledge of the geography of the town by Bowen Buckman in the year 1843." At the top of the map is the label "Fulton Village." This was present-day East Woburn, or Montvale, named in honor of Robert Fulton.

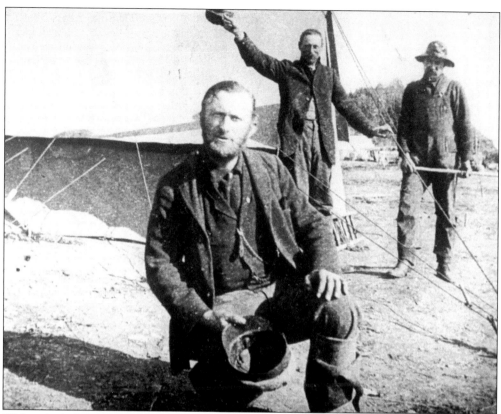

Woburn's Arthur W. Whitcher, proprietor of the Pill Box drugstore, is seen here in Alaska in September 1898. Whitcher is credited with coining the name "Busy Bend," for the area long known as Woodberry's Corner.

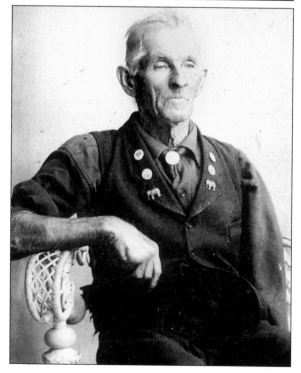

Waterman "Wat" Brown (1818–1900) worked for the Boston & Lowell Railroad for 65 years. He started working for the company in 1834 and continued until 1899, despite the loss of an arm in an accident in 1850. Brown designed his own gravestone at Woodbrook Cemetery; it was constructed of original rails that he had saved for that purpose.

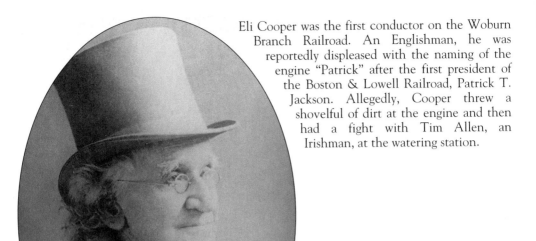

Eli Cooper was the first conductor on the Woburn Branch Railroad. An Englishman, he was reportedly displeased with the naming of the engine "Patrick" after the first president of the Boston & Lowell Railroad, Patrick T. Jackson. Allegedly, Cooper threw a shovelful of dirt at the engine and then had a fight with Tim Allen, an Irishman, at the watering station.

Harry W. Wade, 6 years old, dressed as the fireman mascot in the parade for the dedication of the Soldier's Monument on October 14, 1869. Wade was born June 19, 1863 and lived into his nineties.

Charles S. Converse is pictured at age 40. He was first a lieutenant in Company G, 5th Regiment (1862–63) and later became a captain in the same regiment.

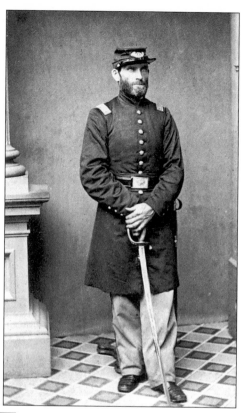

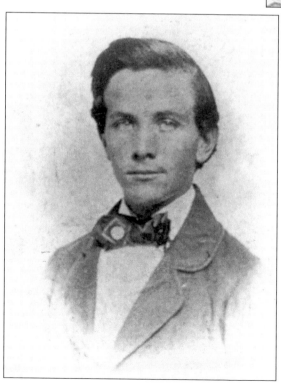

William H. Hoskins of Company K, 39th Regiment, died in 1864 from wounds inflicted during a battle in the Civil War. He was 23.

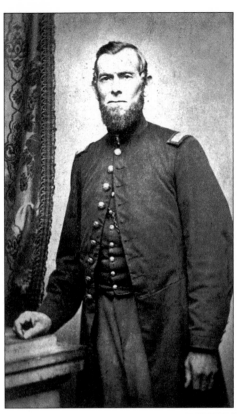

Capt. John I. Richardson of Company K, 39th Regiment, is pictured here in 1862. He died during the Civil War at age 44.

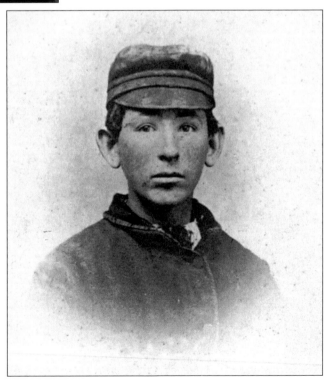

Michael Finn of Company K, 39th Regiment, was killed at Spottsylvania, Virginia, on May 8, 1864. He was 16 years old.

Amelia J. (Andrews) Parker was a member of the first class to graduate from Woburn High School in 1855. She later taught school in the Highlands (the Green Street area) and in 1879 became the first Woburn woman to pay a poll tax for the purpose of voting. Women in Woburn voted for the first time in 1880, for the school committee.

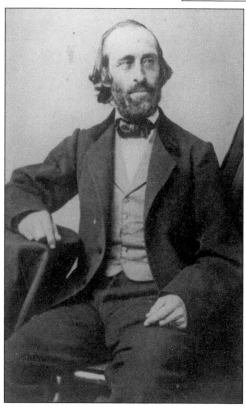

Parker L. Converse (1822–1899) was a lawyer, a judge, and the author of *Legends of Woburn*.

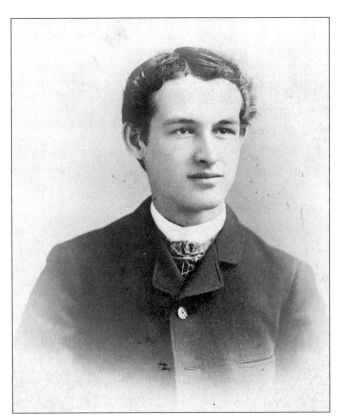

Adm. Charles Wellman Parks was born in Woburn in 1863. He graduated from Woburn High School in 1879 and entered Rensselaer Polytechnic Institute at Troy, New York. He graduated with a degree in civil engineering and is pictured here in the year of his graduation, 1884. He was commissioned a civil engineer with the rank of lieutenant in the U.S. Navy in 1897 and rose to the rank of rear admiral in 1918. Among other achievements, he was responsible for the development of Pearl Harbor for naval purposes. He died on June 30, 1930.

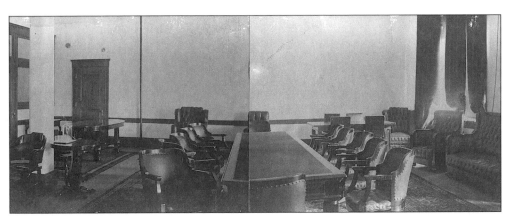

This is the room in Portsmouth, New Hampshire, in which the Russo-Japanese peace treaty sessions were held. Adm. Charles Wellman Parks was in charge of making the preparations for this event. One of the chairs in this room was given to the Woburn Public Library by Parks's widow. It was the chair used by the Russian delegate to the Treaty of Portsmouth, Sergei Witte. Pres. Theodore Roosevelt presided over the sessions.

Aaron Thompson (1817–1888) was superintendent and treasurer of the Woburn Gaslight Company for 32 years. He had earlier been employed by the Boston & Lowell Railroad at the Woburn Center Station where he was ticket seller, freight agent, baggage master, and switchman—all at the same time.

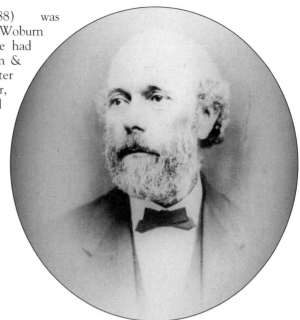

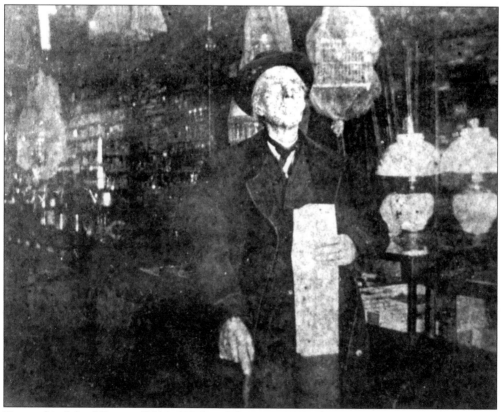

Pictured is John Wyman (1814–1896) in Thompson's Hardware Store in 1890. Wyman was one of three who founded the Woburn Mechanic Phalanx in 1835. He became blind in 1887. He lived at 1 Kilby Street and later moved to Charles Street.

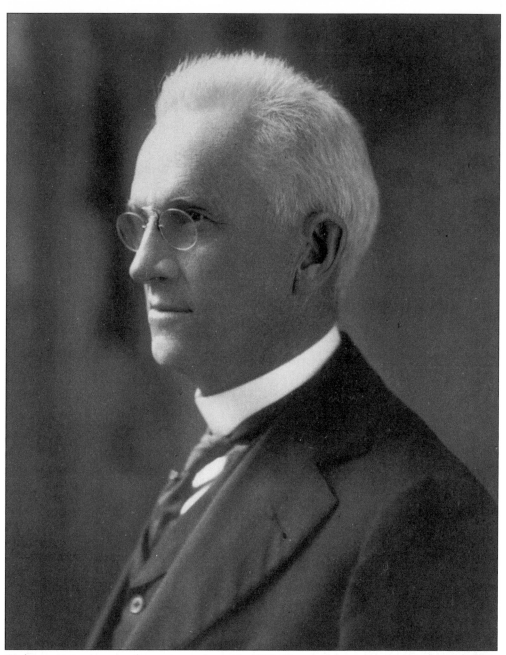

Woburn was incorporated as a city on June 12, 1888. The vote for a city charter was 966 to 32. The first election held under the city charter was on December 4, 1888. Edward F. Johnson, a descendant of Capt. Edward Johnson, the Father of Woburn, was elected the first mayor. Johnson (1856–1922) served in 1889 and 1890. He was also judge of the Woburn District Court for 31 years and a member of the Woburn Public Library Board of Trustees.

Four

STREET SCENES

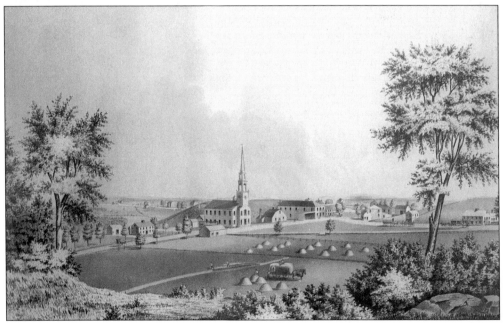

This drawing is called *A View of Woburn in 1820*. The scene is Woburn Center as surveyed from Academy Hill (Warren Avenue). The Congregational church (later Unitarian) is in the center of the drawing.

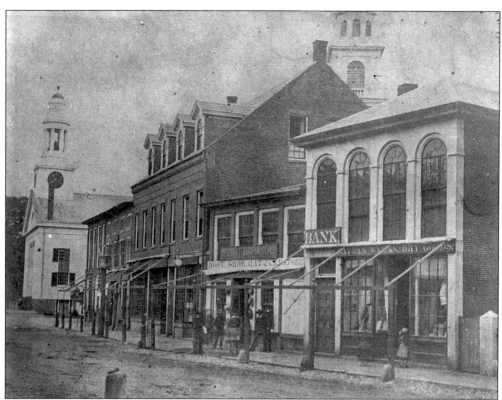

This view of John Wade's property on the square in 1856 is believed to be the first outdoor photograph taken in Woburn. The Congregational church is on the left. This building was later bought by the Unitarians, who moved it back on the lot and remodeled it. On the right is a stone gatepost, which marks the entrance to Wade's garden; his home was in the rear. The building with the four dormer windows was constructed in 1846 and was the first structure in town to be built entirely of brick. It was later the location of Silverman's.

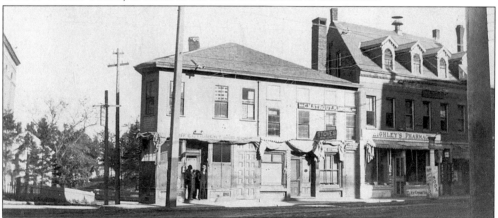

This is an 1895 view of the corner of Park and Main Streets, the Wade Block. John Wade purchased this property in 1805 and opened what was only the second store in this area. He sold rum and dry goods. In 1900, the building was raised and a new first floor was added. The building on the right with the dormers is still there, but with a new facade. In 1825, Wade sold his store to Bowen Buckman and by 1850, he was considered the wealthiest man in town.

This view of Woburn at the close of the Civil War was taken looking north on Main Street. John Wade's property is on the left. The Universalist church, on the corner of Main and Walnut Streets, was erected in 1844. It was later used by the Methodist society. The first high school classes were held in 1852 in the Knight Building, next to and north of the church. Both the church and the Knight Building were lost in the fire of 1873.

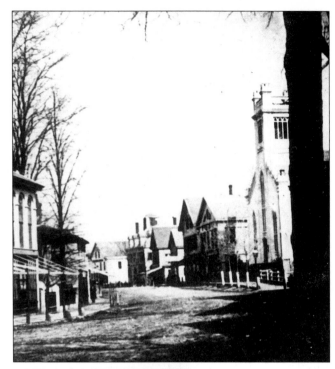

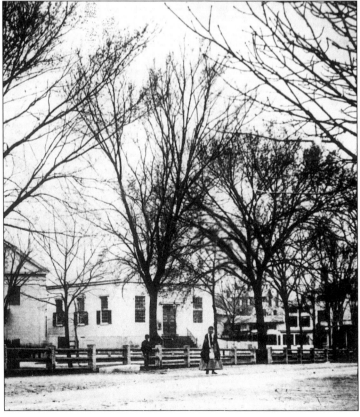

Central Grammar School and the Woburn Town Hall are shown here, c. 1865. Both were located on Common Street, now the site of the city hall. The large house on the right was Dr. Drew's; it was moved to Prospect Street when the railroad was built across Pleasant Street.

53

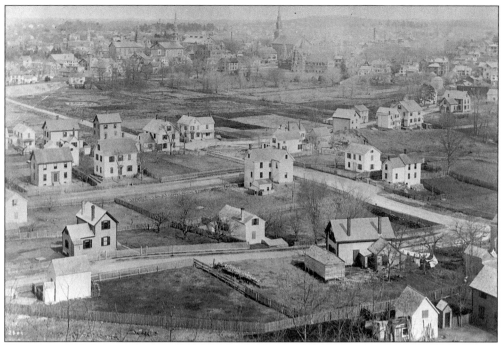

This view of Woburn was taken from Rag Rock in 1889. The library is visible in the distance, center, and the spires of the three churches around the common can also be seen.

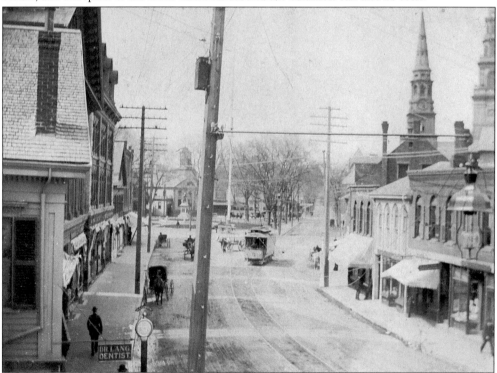

Lyceum Hall is on the left in this view, taken in 1897 looking south to Woburn Common. The Wade Block is on the right, and the spires of the Unitarian and Baptist churches rise above it.

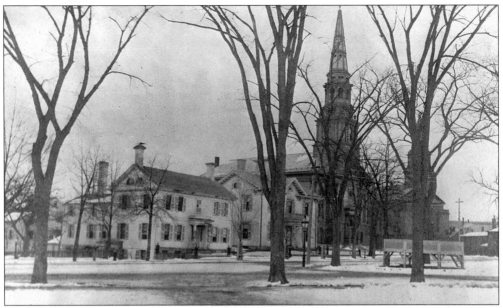

This is a view of Pleasant Street before 1887. Shown, from left to right, are the Hinckley House, now the site of Fleet Bank; the Jonathan Bowers Winn Mansion; the Unitarian church, with the tall steeple; and the Baptist church.

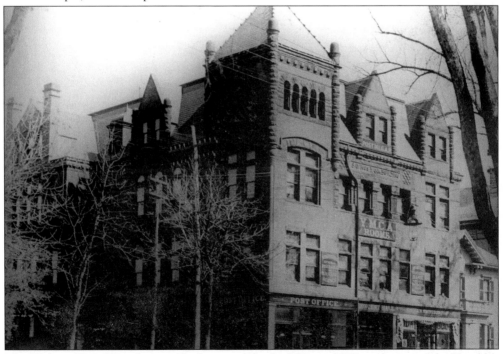

The Woburn Five Cents Savings Bank erected this building in 1887 on the site of the Hinckley House. When this photograph was taken in 1895, the building was occupied as follows: street floor by the A.W. Whitcher Drugstore and the post office; second floor by the bank, the S.B. Goddard Insurance, and the school department offices; third floor by the YMCA and the Concert Hall; and fourth floor by Post 161, Grand Army of the Republic.

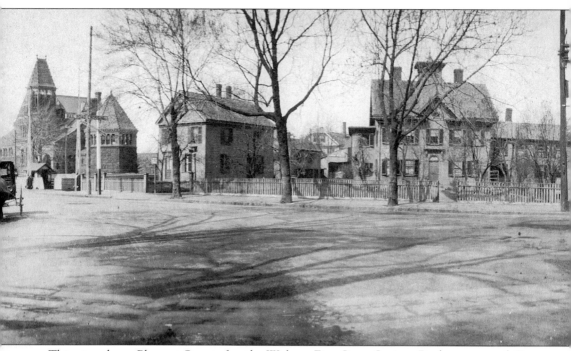

This view shows Pleasant Street after the Woburn Five Cents Savings Bank was erected. From the left are the Woburn Public Library, the Grant House, the Charles Taylor House, the savings

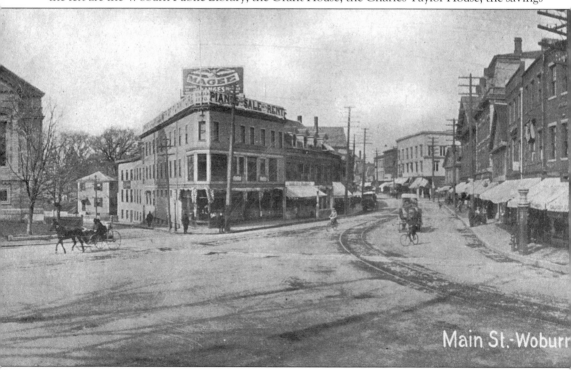

This photograph shows Busy Bend, across the Woburn Common from Pleasant Street. For more than 60 years, the area was known as Woodberry's Corner. Capt. William Woodberry ran a

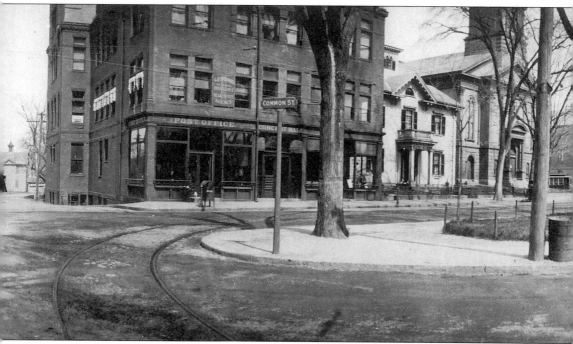

bank, the Jonathan Bowers Winn Mansion, and the Unitarian Church. Notice the sign for Common Street across the street from the bank.

general store here from 1834 until *c*. 1894.

Alvah Buckman poses in front of his shoe store on Main Street in Woburn Center *c.* 1890.

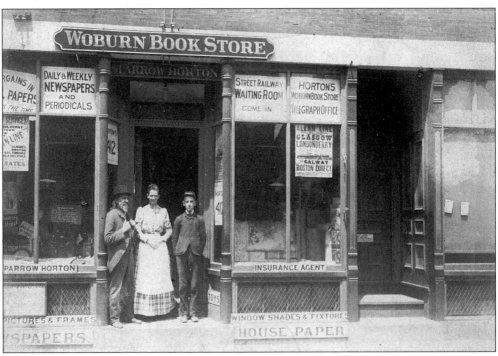

This view shows the Woburn Bookstore, which was located on the west side of Main Street opposite Walnut Street. Posing in the doorway are Sparrow Horton, Hannah Reardon, and Henry P. Harrington. Horton sent the first telegraph message from Woburn on January 22, 1867.

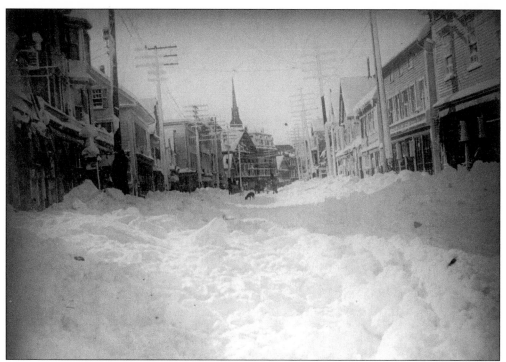

This photograph shows Main Street after the Blizzard of 1898, which struck on January 31.

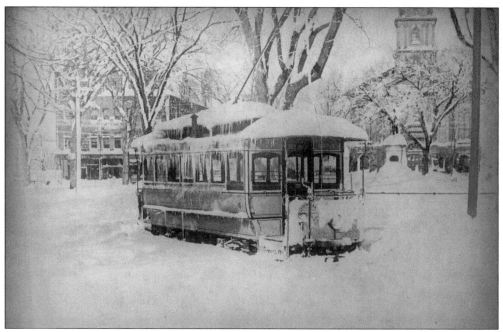

An electric car is left stalled in the snow on Common Street after the Blizzard of 1898.

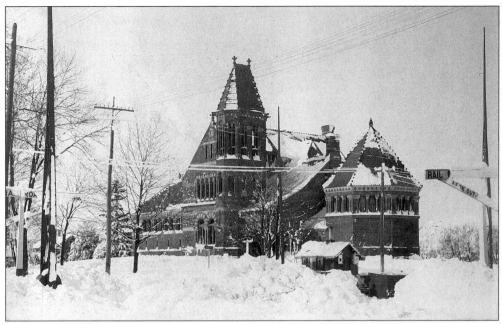

This is a view of the Woburn Public Library after the Blizzard of 1898.

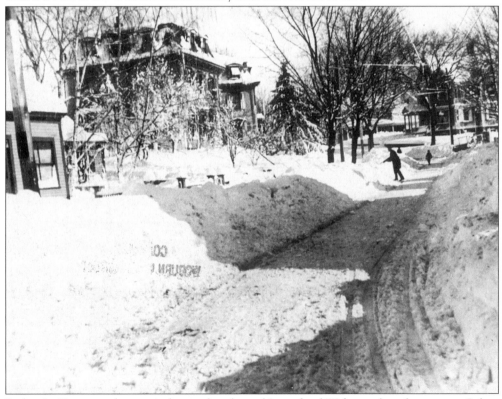

Parker L. Converse, lawyer, judge, and author of *Legends of Woburn*, shovels snow on Salem Street in front of his house after the Blizzard of 1898. Converse was in his seventies. John Bate's Bicycle Shop is on the left. This photograph was taken from Main Street.

The Civil War Monument was dedicated on October 14, 1869. The monument, which stands on Woburn Common, was designed by sculptor Martin Milmore at a cost of $6,000, paid for by the Town. According to William Cutter, librarian of the Woburn Public Library, the posts surrounding the monument were taken from the upper locks of the old Middlesex Canal in the late 19th century.

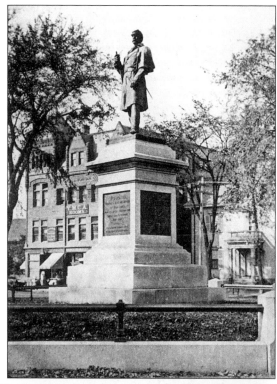

A curious monument on Woburn Common is the ventilator cowl from the USS *Maine*, the battleship that blew up in Havana Harbor on February 15, 1898. Arthur Whitcher, the same gentleman who named Busy Bend, had the idea of acquiring the cowl as a relic of the event.

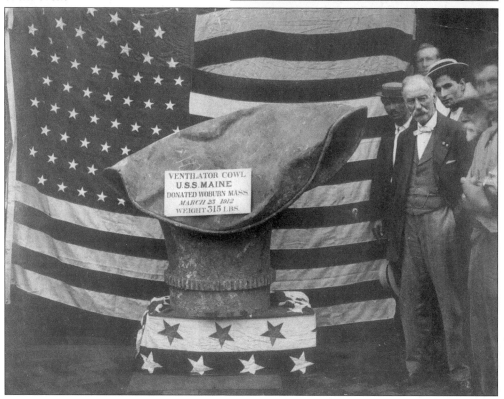

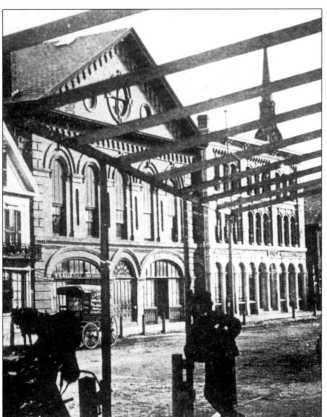

Lyceum Hall, on the left, was constructed in 1855 in response to a need for a suitable lecture hall outside of church vestries, which had been used for meetings and lectures. Woburn's Lyceum Hall procured speakers such as Oliver Wendell Holmes, Henry Ward Beecher, and Ralph Waldo Emerson. This 1863 photograph shows the new bank building, which later became the Woolworth Block at 397 Main Street.

This view of the east side of Main Street is similar to the one on the left, but a fourth story has been added to the bank building. In 1934, the upper stories were removed from Lyceum Hall, which in later years was was occupied by Adrian's and Thom McAn.

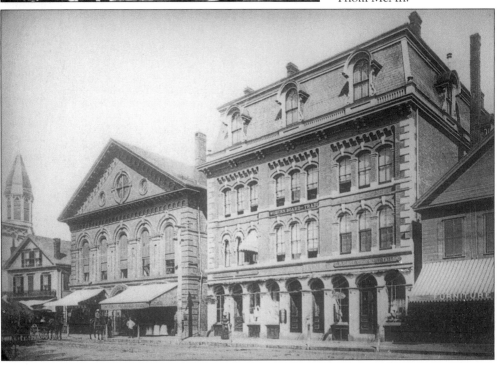

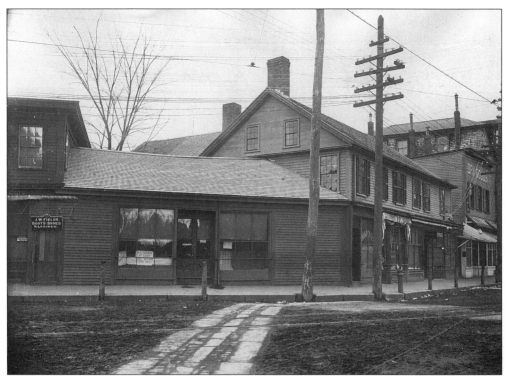

This is a view of Woodberry's Corner early in 1894. Now called Busy Bend, Woodberry's was located on the east side of Main Street, opposite Park Street. Later, this was the location of Murphy's Drugstore. The store on the right with the awning is the present location of Moore & Parker.

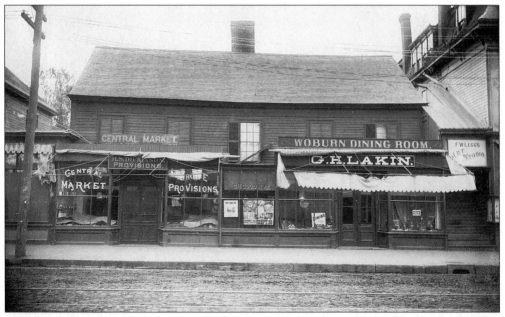

Pictured is Main Street before 1900. The location of the Woburn National Bank, now Citizens Bank, was probably just north of this view but may have included the central market location.

This view is south of Woburn Center. St. Charles Church is on the right, just beyond the Sun Light Company. The Dow Estate is visible at the far right. The estate had a terraced lawn

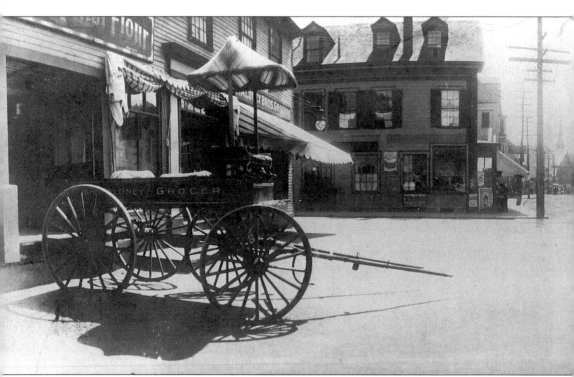

This photograph was taken looking south on Main Street from the junction of Campbell and

that extended down to Main Street. The remains of stone steps are still visible.

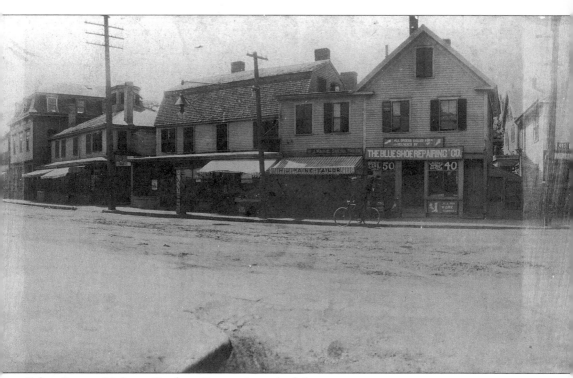

Salem Streets. Maloney Brothers Grocers is on the left.

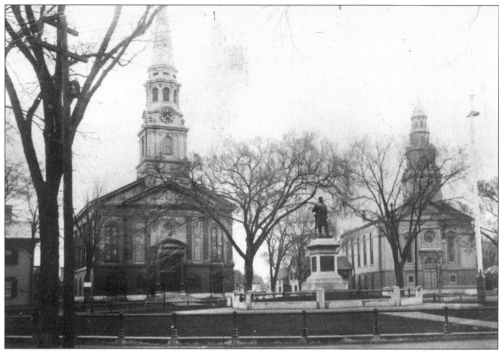

This photograph was taken looking across Woburn Common from Main Street. It shows the Unitarian and Baptist churches. In the 1920s, the Unitarian steeple was toppled by a tornado.

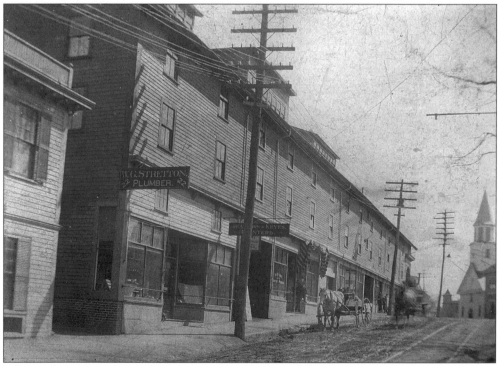

A horse-drawn carriage awaits on Montvale Avenue, while another one is a blur as it moves down the street. Woburn Auditorium, on the left, was destroyed by fire in 1917.

Five

SCHOOLS AND SCHOOLCHILDREN

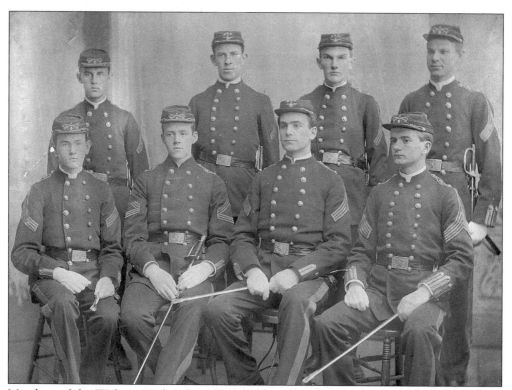

Members of the Woburn High School Battalion pose in 1894. They are, from left to right, as follows: (front row) Capt. A.? Carter, Lt. Charles Carter, Capt. Philip M. Brown, and Maj. Benjamin S. Hinckley; (back row) Lt. Frank H. Smith, Lt. Chester Fowle, Lt. John C. Andrews, and Capt. Daniel B. Dimick.

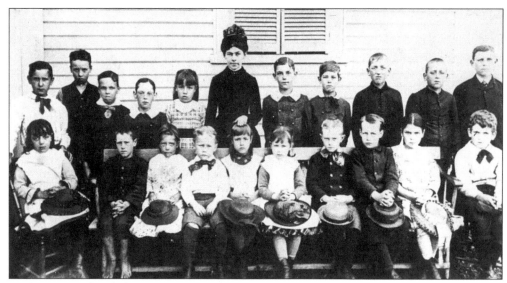

Students from the Cedar Street School pause to have their picture taken in 1883. The school was located in East Woburn.

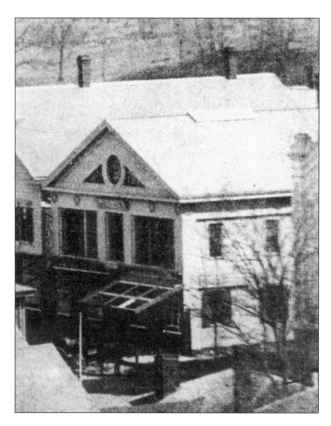

The Knight Building, located north of Walnut Street on the east side of Main Street, was where the first high school held classes in rented rooms in 1852.

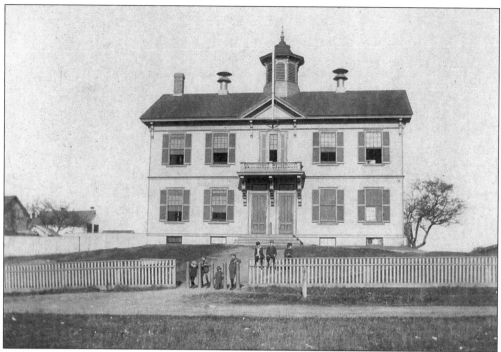

The Plympton School lot was selected in December 1859 by the Town of Woburn, which bought the property from the Plympton heirs. The school, seen here, was built soon afterward.

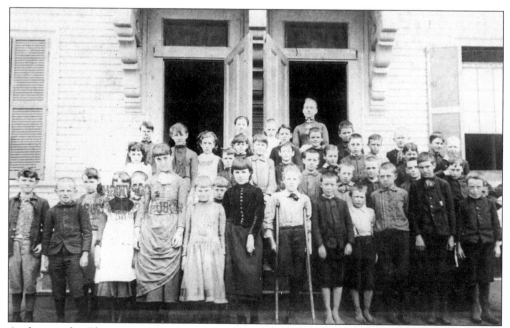

A class at the Plympton School poses in front of the building, which lasted until the 1960s when it burned down. A new Plympton School was rebuilt on the site.

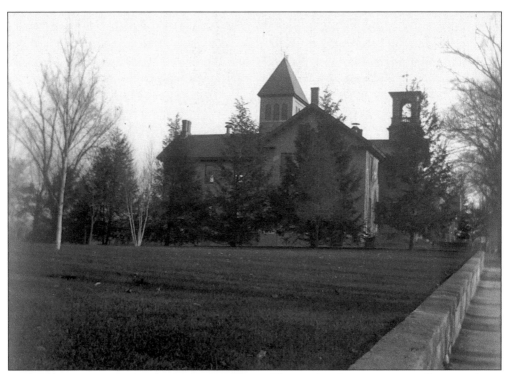

Warren Academy was originally erected in 1828, partly consumed by fire in 1838, and destroyed by fire on February 11, 1948. It was located on Academy Hill (Warren Avenue), which was deemed to be the most beautiful spot for such a seminary.

The old West Side Schoolhouse was built by the Town of Woburn in 1794–95. It originally stood at the junction of the old road leading to Lexington and Cambridge Street. In 1831, it was moved south to the corner of Pond and Cambridge Streets. When the Town of Winchester built a new West Side School in 1851, the old Woburn school was sold and converted into a dwelling house.

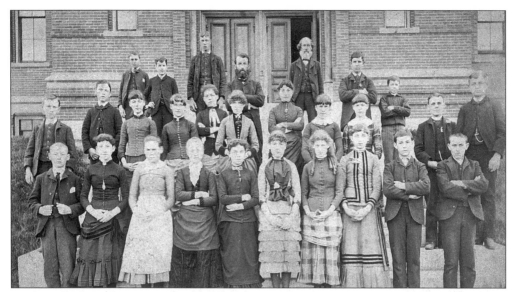

Students and teachers from the Cummings School pose for a photograph in 1885. The Cummings School was located on Warren Avenue where the elderly housing complex now stands.

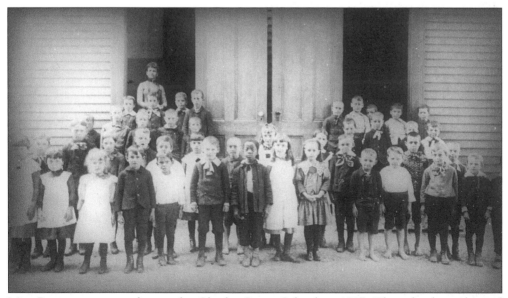

Miss Bowers was a teacher at the Charles Street School in 1888. The school was located on Charles Street, which is just beyond Hammond Square and before Frances Street, off Main Street

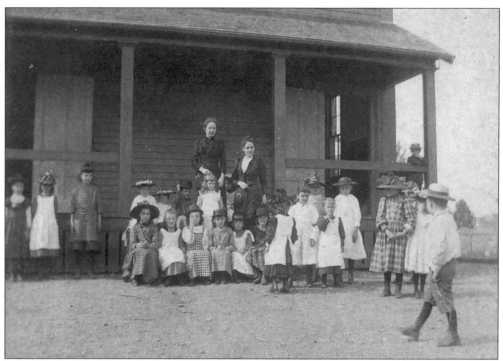

This undated photograph shows the Morse Street School on a day when most of the students were wearing hats. The teachers are Anne Caulfield, left, and Annie A.J. Larkin, right.

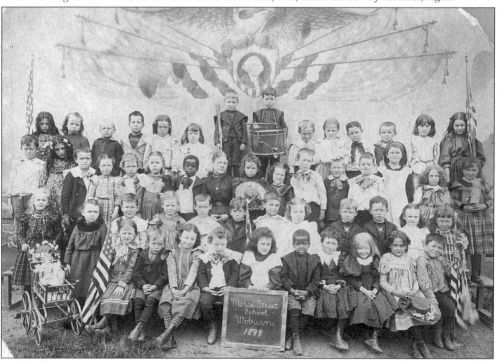

The Morse Street School celebrates one of the national holidays in 1899. The teacher is Miss Blake. The Morse Street School was located off Reed Street.

Thomas Emerson (1834–1903) served as superintendent of public schools in Woburn and also as superintendent of the Unitarian Sunday school.

The photograph below shows students Grace Peppard, Edith Howe, and Emily Sanborn with Miss Russell, teacher; Mr. Hoag, principal; and Thomas Emerson, superintendent of schools. Neither the school nor the date is identified; however, "May 6, '97" is written on the blackboard.

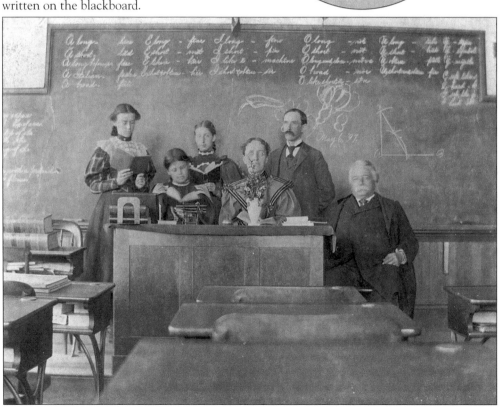

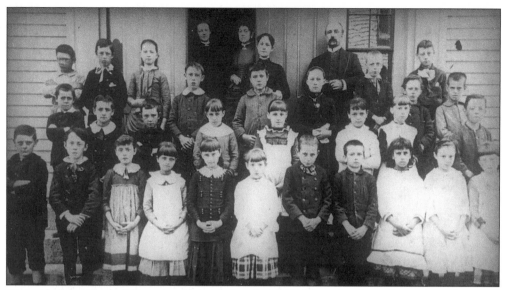

Pictured is the Central Grammar School class in 1885. The school was located on Common Street near the present site of Woburn City Hall.

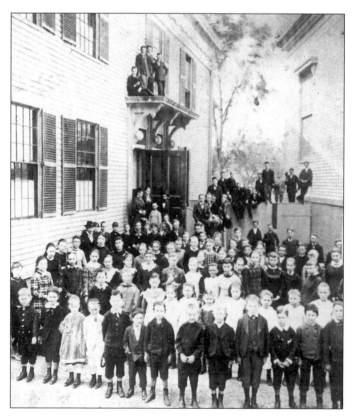

Another class is pictured at Central Grammar School. This one is identified as the fourth-grade class in 1878.

The first high school was called the Hudson School. Located on Main Street, it was built in 1855 at a cost of $11,701.99. It was used as the high school until 1907. It was later called the Hanson School. Eventually, the school was torn down; its location is now the parking lot next to the former Kenney's Deli.

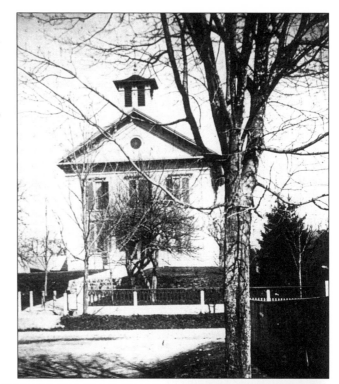

Pictured below is the Woburn High School chemistry class in 1889. H.B. Dow was the chemistry teacher.

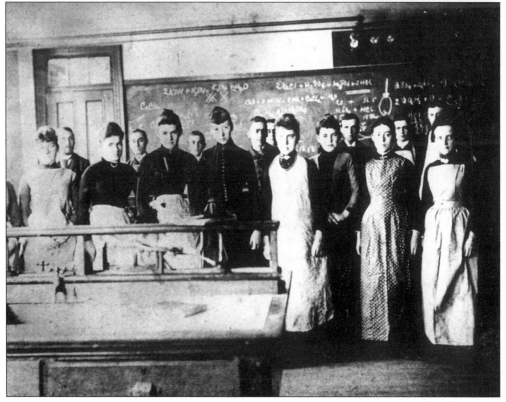

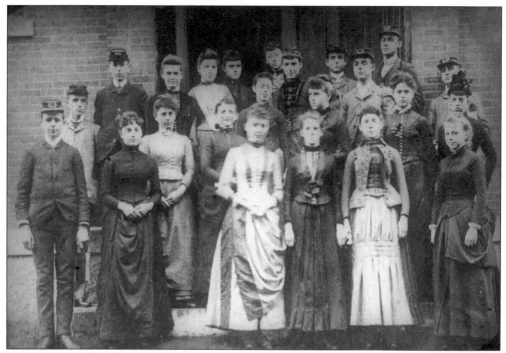

This is the Woburn High School Class of 1890, posing in May 1888. The class may be standing in front of the first high school building, the Hudson, to which a brick extension had been added.

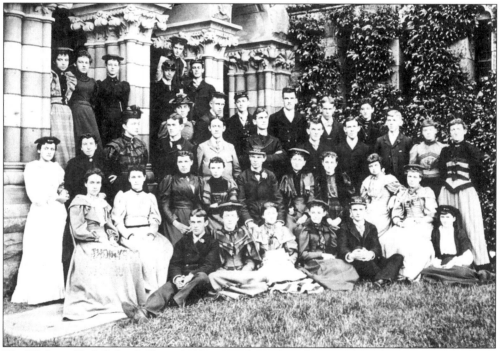

The Woburn High School Class of 1894 poses for a class photo to the right of the front portico of the Woburn Public Library.

Six
WOBURN PUBLIC
LIBRARY

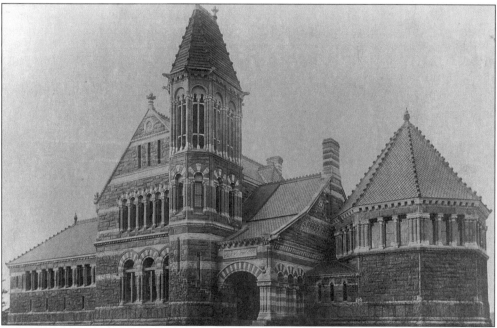

The Woburn Public Library, designed by Henry Hobson Richardson, opened in May 1879. This view was taken *c.* 1887. The building became easily the most recognizable spot in the community and a source of considerable pride as well. The donor, Charles Bowers Winn, wanted it to be an ornament to the town, and he more than got his wish. He did not want his name on the building, as was so often the custom in those days, but instead thought that it should be called something like the Woburn Public Library. In 1987, the Woburn Public Library was designated a National Historic Landmark.

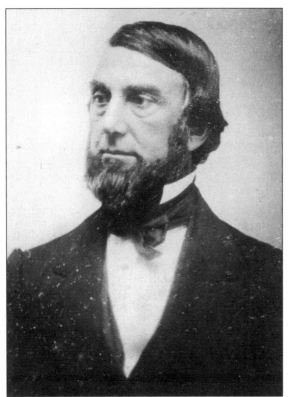

Jonathan Bowers Winn (1811–1873) was born in Burlington. In 1841, he established the firm of J.B. Winn & Company in a factory on the north side of Salem Street, known today as Winn Park. In 1853, he was a delegate to the State Constitutional Convention and offered his fee of $300 to the Town to start a public library. The Town agreed and the library was authorized in 1855.

The Jonathan Bowers Winn House once sat on what is now the library lawn. It was moved in 1879 to a site between the Unitarian church and the Hinckley House (now the site of a bank). Through the years, the house was used as a hotel, restaurant, and rooming house. At one time, it was called the Woburn House. The building was destroyed in the 1930s.

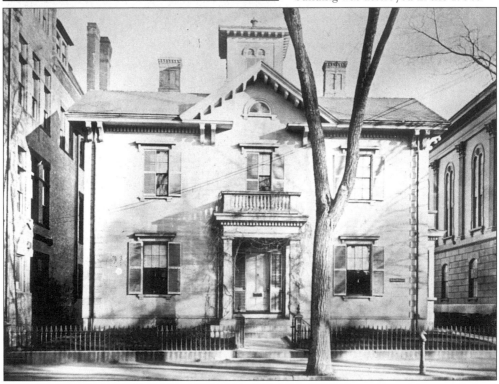

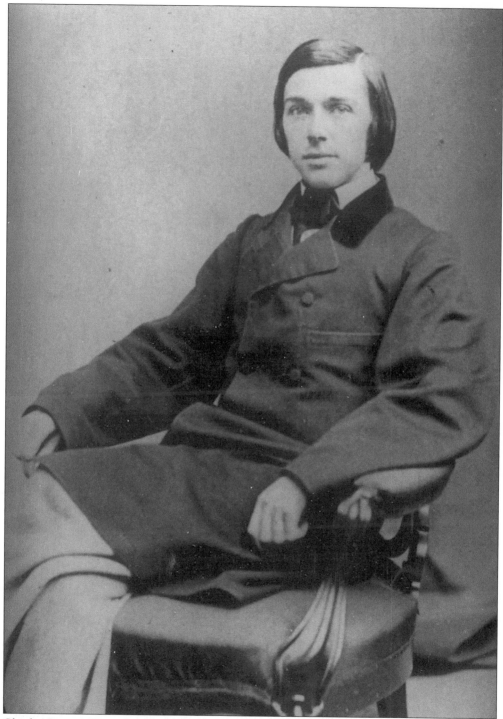

Charles Bowers Winn (1838–1875) left the bulk of his estate to the Town of Woburn for the establishment of a public library. He made the donation in honor of the memory of his father, Jonathan Bowers Winn, who had died just two years earlier.

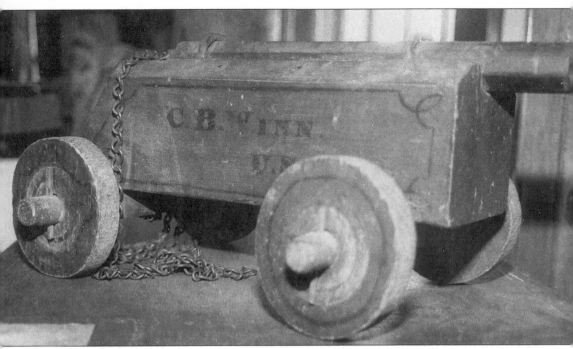

This photograph shows the toy cannon that Charles Bowers Winn played with when he was a child. The toy was donated to the Woburn Public Library by Winn's former brother-in-law Edward Hayden, who was on the Woburn Library Committee charged with building the new library. Hayden was the widower of Winn's sister Marcia, who died in childbirth. This cannon was one of many items that the committee collected over the years to support its plan to have the library house an antiques department that would serve to educate the community about its history.

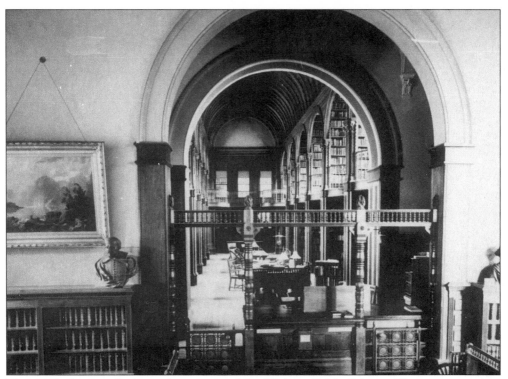

This 1889 photograph shows the interior of the Woburn Public Library. The view was taken from the reference room, looking into the study hall. Much of the interior remains the same today, more than 100 years later.

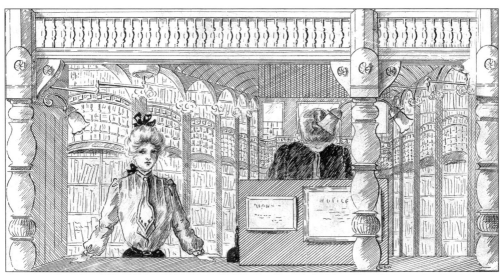

This is a sketch of the original charging desk (circulation desk) of the Woburn Public Library, drawn by Louise E. Wyman of Woburn, who later married William Ruhl. The original desk was at the entrance to the study hall.

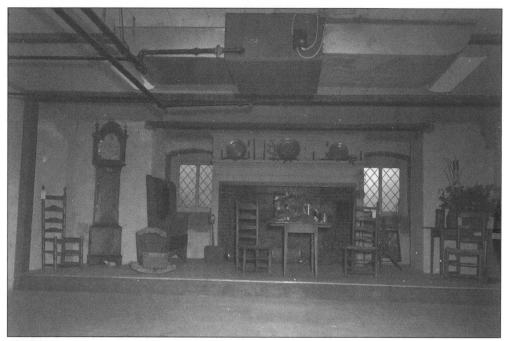

The basement of the library once housed the Antique Kitchen, which contained items donated to the library for its museum. The area was set up to show how people from times gone by went about their daily lives. Today, the area is the children's department of the library.

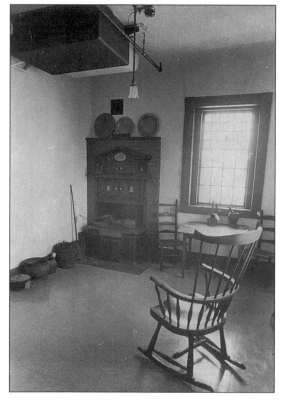

The second floor of the library had a suite of rooms once used by the live-in janitor. This room was the janitor's kitchen. Here, it is set up as the Antique Kitchen that was in the library basement until space constrictions forced its relocation to the second floor.

William R. Cutter (1847–1918) was the second person to serve as librarian of the Woburn Public Library. He was selected to succeed George Mather Champney, who died suddenly in the library after after returning from lunch one day. Cutter was very involved in local history and was the author of a number of books on genealogy.

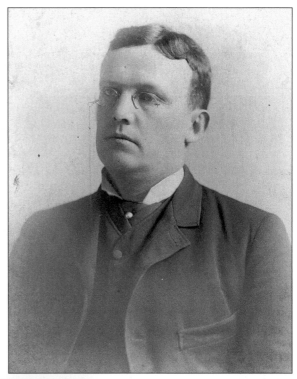

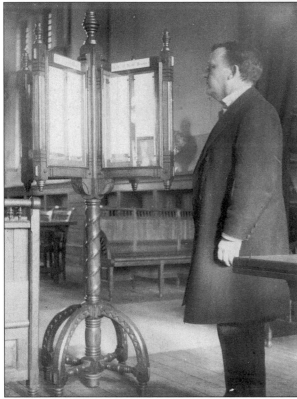

Librarian William R. Cutter peruses the latest best-sellers list, posted on a stand in the library's reference room in 1896.

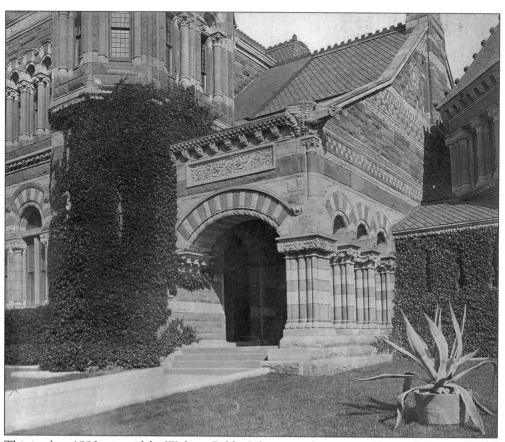

This is a late-1880s view of the Woburn Public Library porch entrance. Notice the gargoyle and other interesting faces carved into the area above the porch.

This photograph taken in August 1884 shows the rear of the Woburn Public Library and the Fosdick House, which later became the Towanda Club.

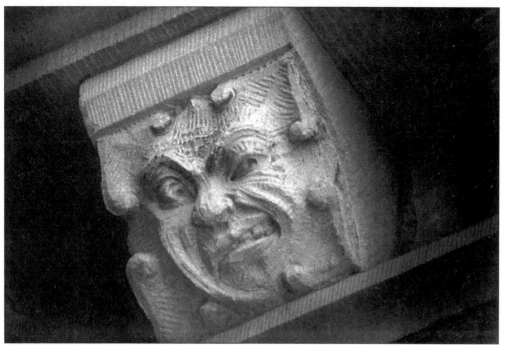

This detail shows one of the grotesques on the Woburn Public Library building. (Photograph courtesy of Joe Brown.)

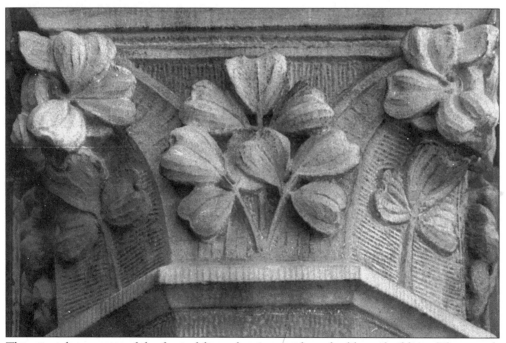

This view shows some of the fancy foliage that is carved on the library building. (Photograph courtesy of Joe Brown.)

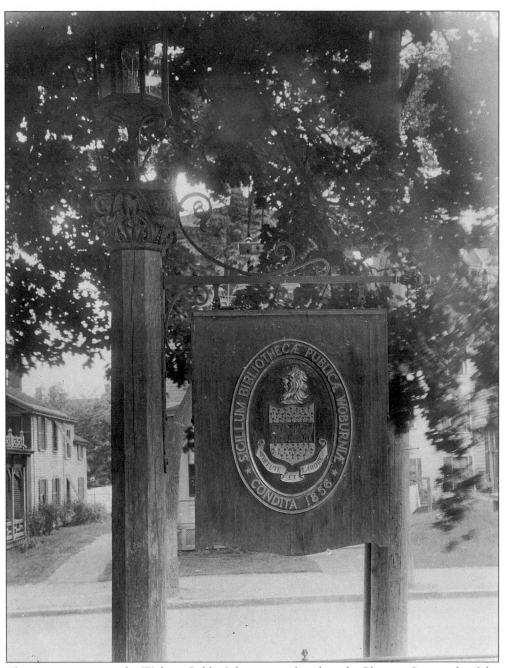

This sign announcing the Woburn Public Library was placed on the Pleasant Street side of the building nearly a century ago. The library trustees had heard that many visitors to the community were mistaking the building for a church and that one man had even indicated his intent to attend services there the following Sunday. The trustees had the sign produced shortly thereafter.

Seven

WOBURN AT WORK AND PLAY

LAST NOTICE!

The Assessors of Woburn hereby give Notice, that they are about making up and completing a list of Real and Personal Estates for the current year; and all persons whe have NEGLECTED to present a proper and satisfactory list of Personal property; and all who have presented an UNSATISFACTORY list, will be DOOMED, unless they present such lists as will satisfy the Board.

The assessors will be in session at the Town House to receive the above information, any buness day between the 8th and 15th of July.

CYRUS THOMPSON,
LEONARD THOMPSON,
JOHN CUMMINGS, ASSESSORS
CHAS. CHOATE, OF THE
N. A. RICHARDSON. TOWN OF WOBURN.

WOBURN, JUNE 28, '50.

The assessors of the Town of Woburn took their work *very* seriously, as indicated by this broadside.

John E. Russell was the first conductor on the North Woburn Street Railway. Noted for his amiability, he often halted the car in the town center and went off to do errands for the women of North Woburn.

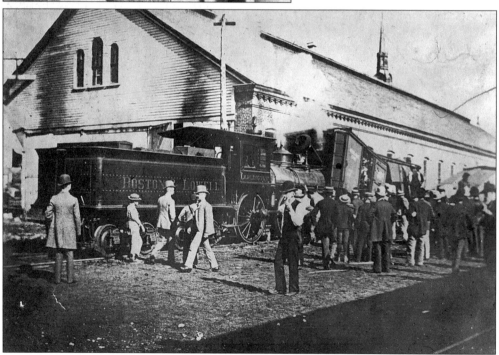

In 1888, Cy Chase, engineer of the locomotive Arlington, ran into Hart's express car. The man in the foreground wearing a derby and smoking a pipe is George Buchanan.

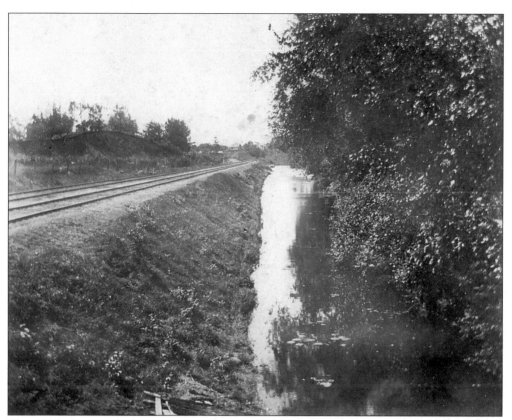

This 1898 photograph shows a section of the Middlesex Canal near Lowell Street.

In March 1809, this broadside offered the successful applicant an opportunity to earn from 5¢ to 50¢ a head for a musquash or mink taken on the Middlesex Canal.

BOUNTY

ON

M squashes and Mink,

TAKEN ON THE

Middlesex Canal.

IF within two rods of the Canal, 50 cents a head ; quarter of a mile, 30 cents ; half a mile, 10 cents ; one mile, 5 cents.

Application to be made either to Mr. Cyrus Baldwin, Mr. Nathan Mears, Col. Hopkins, Mr. Isaac Johnson, Mr. Elijah Peirce, Mr. Samuel Gardner, or Mr. Joseph Church, whichever of them lives nearest the place where the animal may be taken.

If the person applied to is satisfied of the facts, his certificate or verbal declaration thereof to the subscriber will entitle the applicant to the bounty. The applicant must produce the Musquash or Mink entire, to one of the above-named persons. He may then take his skin.

MARCH, 1809. J. L. SULLIVAN.

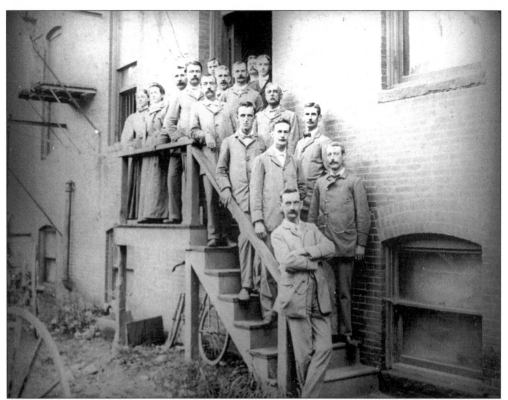

The post office staff gathers for a group photograph in 1894. The post office had recently moved from the Dow Block on the corner of Main Street and Church Avenue into new quarters in the Woburn Five Cents Savings Bank building on Pleasant Street.

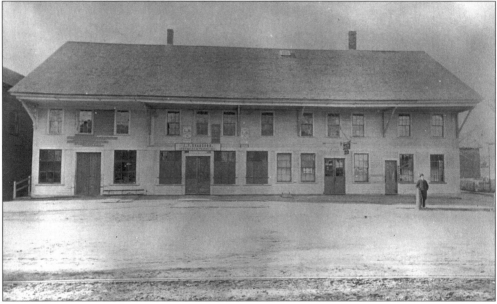

This 1880 photograph shows the J.F. Dearborn Groceries company in the old Nichols and Winn Shoe Factory in North Woburn.

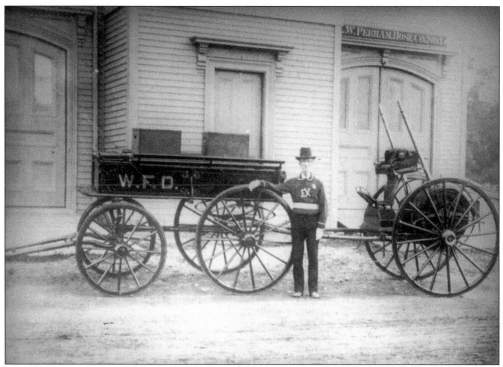

The Woburn Town Fire Department organized in 1851 under an act of the legislature. Pictured is the L.W. Perham Hose No. 1.

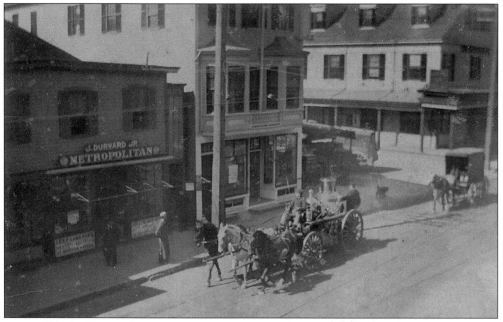

The three-horse hitch steamer travels along Main Street in 1897. The Central House is on the right. The horses were the then well-known team of Tom, Dick, and Harry. The first horse-drawn truck was used in 1885. For the next 30 years, horses powered Woburn's fire department apparatus. In 1915, the first gas-driven equipment was used.

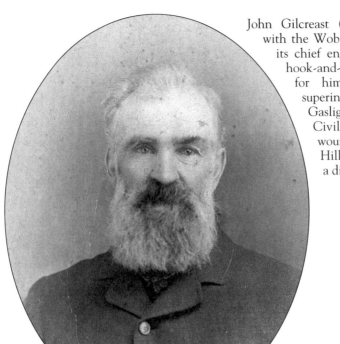

John Gilcreast (1833–1911) was connected with the Woburn Fire Department and was its chief engineer for several years. The hook-and-ladder company was named for him. Gilcreast was also the superintendent of the Woburn Gaslight Company for 31 years. A Civil War veteran, he was wounded in the Battle of Laurel Hill and was discharged with a disability.

Clarence Littlefield (1844–1926) was chief of the the Woburn Fire Department for 16 years. He was also associated with E.G. Barker in the lumber business. A Civil War veteran who enlisted at the age of 17, he was honorably discharged at the end of the war.

Stephen Dow was born in Weare, New Hampshire, in 1809. He married the daughter of Abijah Thompson, who was a wealthy leather manufacturer. Thompson took his son-in-law into the business in 1836. After Thompson's death, the company name changed to Stephen Dow & Company. Dow died in 1887.

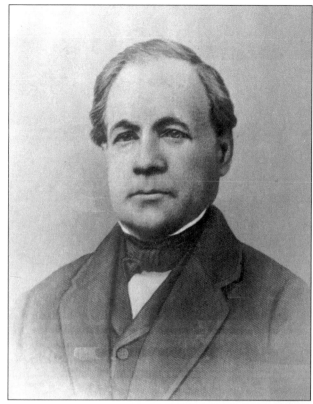

Pictured below is the Stephen Dow & Company tannery on the corner of Pleasant and Water Streets in 1877. After a fire destroyed the plant in 1893, a new building was erected on Cross Street.

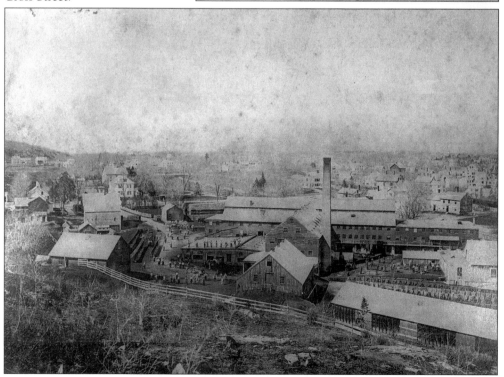

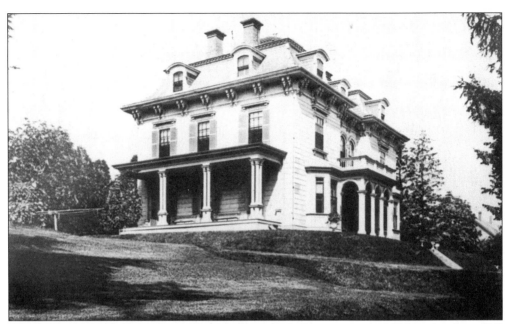

Abijah Thompson, father-in-law of Stephen Dow, built this mansion in 1853 on Academy Hill (Warren Avenue). Later known as the Dow Mansion, the house was situated between Court and Myrtle Streets. It was taken down some years ago.

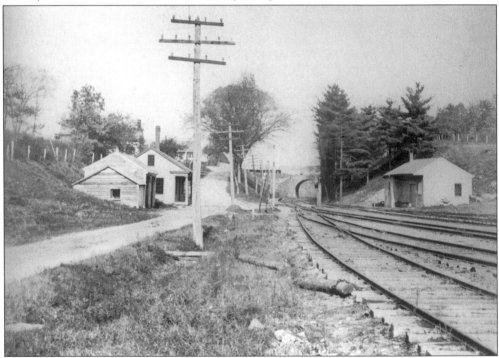

The Old Watering Station was built in 1835 by the Boston & Lowell Railroad on the west side of the tracks a few hundred yards south of the Salem Street Bridge. In later years, it was called the Walnut Hill Station. It was reportedly the oldest station in the United States when it burned in 1894.

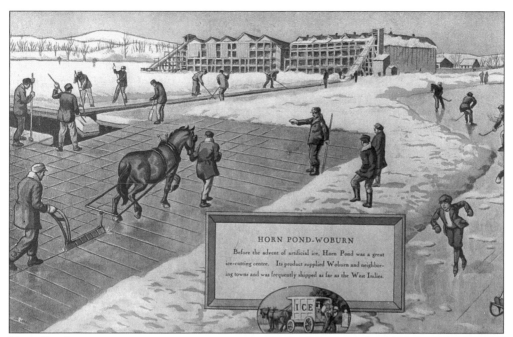

Horn Pond was at one time a great ice-cutting center. Commercial ice harvesting originated during the life of the Middlesex Canal. Horn Pond soon became a major supplier of cut ice to the Boston area and beyond. (Louis Linscott print.)

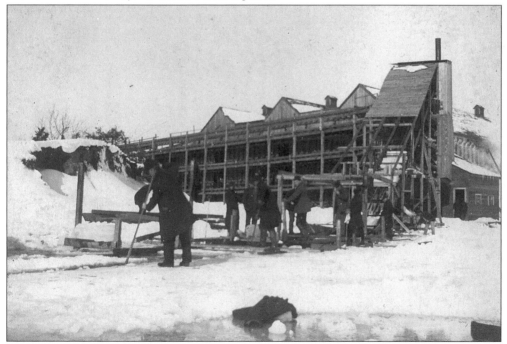

Ice cutting and harvesting is under way at Horn Pond in 1896. From earliest times, ice was harvested and stored in icehouses. When cut and packed in sawdust, it kept in storage for a year. Throughout the summer months, the sale of ice was an important business until home refrigeration became common.

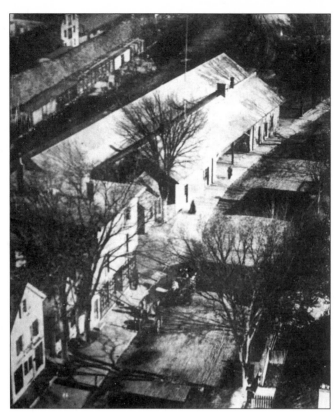

The first railroad station, located on the corner of Main and High Streets, was built in 1844 and operated until 1867. It was 127 feet long and 31 feet wide. In 1853, a train shed was added. It was replaced in 1867.

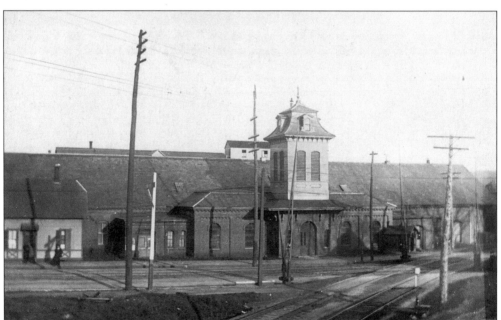

The second railroad station was built of brick in 1867 and replaced the original of 1844. This one was located on the corner of High and Main Streets. It was replaced in 1886 when the way station was built where the new extension, or loop, to Wilmington crossed Pleasant Street.

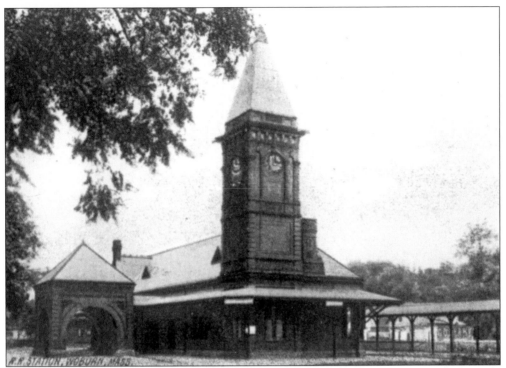

The third railroad station, which replaced the brick station on the corner of High and Main Streets in 1886, was located on Pleasant Street. This station was torn down in 1965 to make way for the courthouse on Pleasant Street.

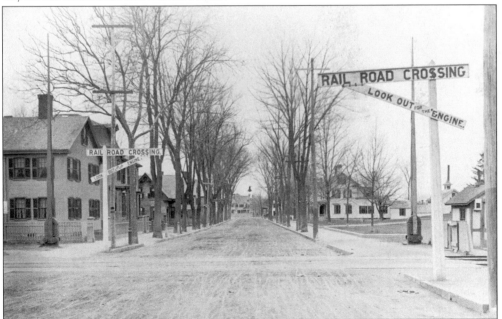

This view of Pleasant Street shows the crossing gates for the train that traveled past the library, which is out of sight on the right side. The train station was located to the left of this photograph. This photograph was taken in the 1880s.

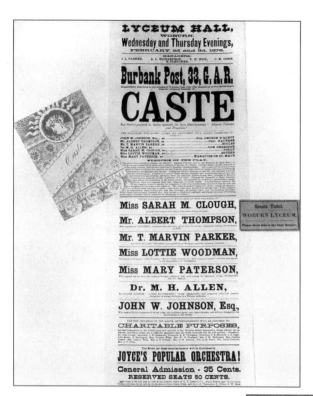

Shown here are a playbill, a program, and a ticket for a performance of *Caste* at the Woburn Lyceum in 1890. The roles were played by local notables, including John W. Johnson, who was a library trustee.

Susan Fowle of Woburn made this sampler when she was 10 years old. The date is 1811. The sampler is in the library's antiques department.

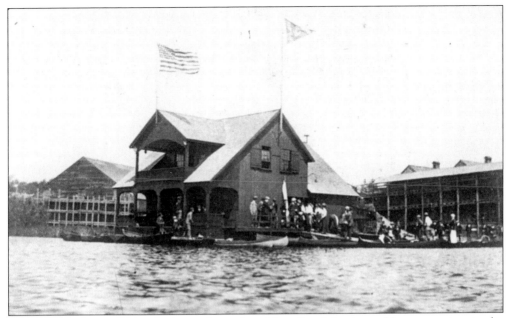

The Innitou Canoe Club, which was located on Horn Pond, is pictured here sometime in the late 19th century. The club was organized on May 20, 1886 with seven members and four canoes. The boathouse was dedicated in June 1892. The Horn Pond Ice Company later purchased the boathouse and tore it down in 1917.

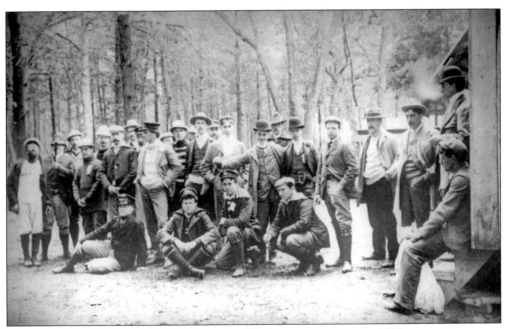

Young men gather on the shores of Horn Pond before a canoe meet in 1898.

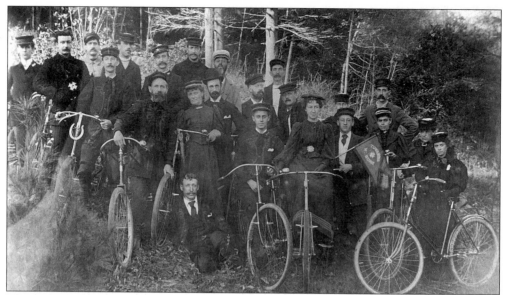

The cycling craze was at its peak when these original members of the Towanda Club posed on October 28, 1894. Pictured here, from right to left, are Edw. T. Brigham, W.F. Estabrook, Elmore A. Pierce, Edw. F. Wyer, Albert Dickinson, Alonzo Pierce, Mrs. A. Dickinson, Walter Richardson, A.L. Holdridge, Harry Marion, F.A. Partridge, Jas. H. Linnell, Fred Masse, Henry H. Leathe, Fred E. Leathe, Mrs. F. Richardson, Fred Richardson, Mrs. W.F. Estabrook, Mrs. Edw. C. Leathe, Mrs. P.K.A. Richardson, and Capt. Edw. C. Leathe.

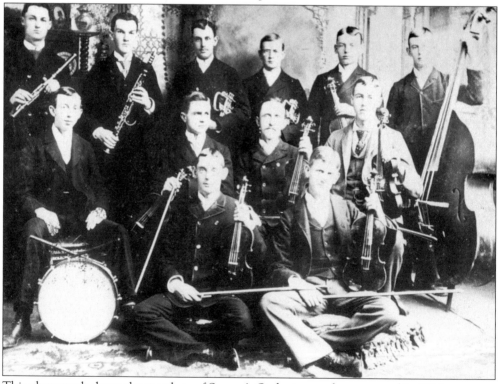

This photograph shows the members of Sawyer's Orchestra, as they appeared in 1894.

This photograph was taken in 1899 at the Towanda Club room on Main Street opposite Woburn Common. In later years, the club relocated to the old Fosdick house near the library.

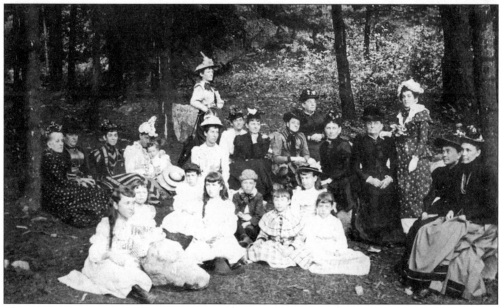

This photograph shows members of the Unitarian church gathered for a picnic. Mrs. Parker L. Converse, wife of the author of *Legends of Woburn*, is seated at the right, facing front, with her hands in her lap.

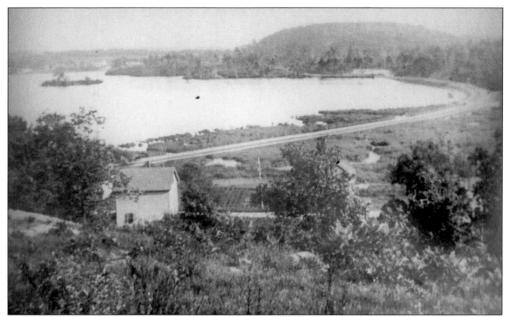

This view of Horn Pond also shows Fowle's Meadow and Brook. The island can be seen in the distance. Well over 100 years ago, this area was a favorite resort for visitors coming on the Middlesex Canal. Boating, picnicking, and bowling were popular attractions on the island. The Woburn Parkway is on the right. Sturgis Street and Water Street are off to left.

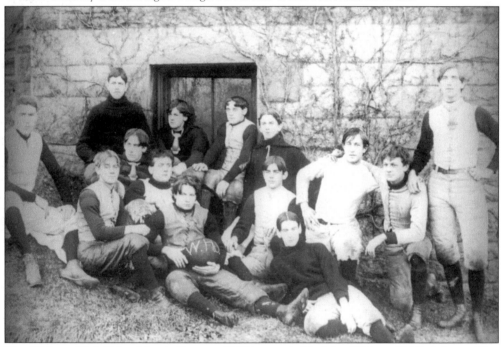

The Woburn High School football team of 1894 poses behind the Woburn Public Library. The players, from left to right, were Frank Sawyer, Billy Fraser, ? Graham, Fred Fowle, Jack Hanson, Sam Hartshorn, Wallace "Pop" Conn, Frank Eaton, Harry Dimick, Sam Bartlett, Tim Winn, Louis Dow, Fred Dow, and Jack McArdle.

Eight
PARTING VIEWS

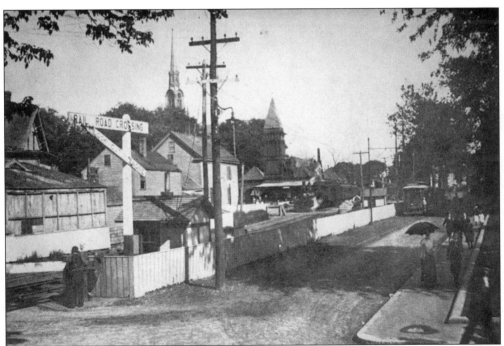

Abbott Street was named for Capt. Samuel Abbott, who owned and operated a lumberyard and wharf on the east side of the Middlesex Canal at the rear of the present Woburn Public Library. The house in the middle of the picture was the home of Alexander Grant, a merchant tailor. Later, the property was owned by Mr. Hartshorne, who operated a livery stable there. For many years, Ownie Doherty kept his dogcart and horse there during the day.

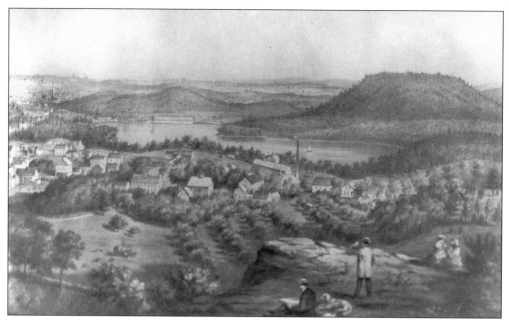

Pictured is a view from Rag Rock in 1863. Horn Pond and Horn Pond Mountain are the chief features in the sketch. Visible in the center is Abijah Thompson's leather factory, which was on the southwest corner of Water and Pleasant Streets. (Sketch by F. Richardson.)

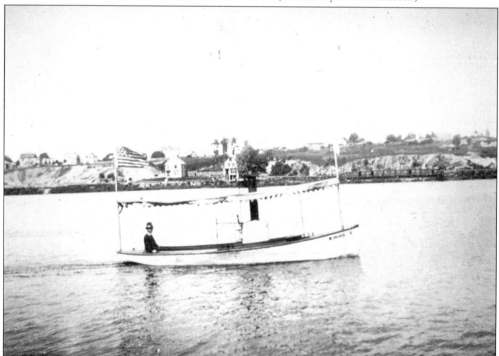

This 1890s photograph shows the steam launch *Winnie D.* operating on Horn Pond, with Charles or William Stevens at the helm. According to local historian Dexter Bulfinch Johnson, the houses on the left side of the shoreline are on Hudson Street and those on the right side are on Kelley's Ledge. Ice cars are on visible on the tracks between Pond Street and Arlinton Road.

This license granted to Charles H. Stevens, master and owner of the *Winnie D.*, indicated that the steam launch could not carry more than nine passengers. The fee was $2 back in 1888.

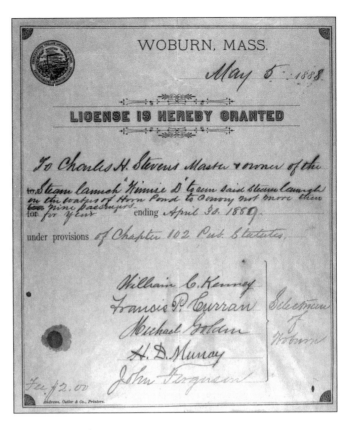

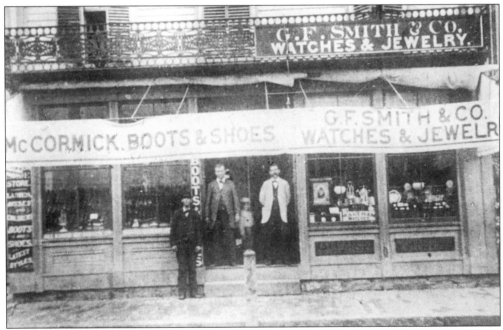

G.F. Smith & Company jewelers was located on Main Street in 1883. It was torn down in 1936.

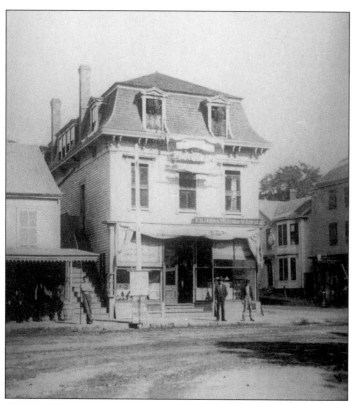

Pictured is the Dodge Block *c.* 1881. Dodge's Jewelry was located here at the corner of Montvale Avenue and Main Street. The Dodge Block was moved to Winn Street after J.W. Johnson and E.F. Johnson purchased the land, which Dodge had been leasing.

James Givens's blacksmith shop was located near John Cummings's tannery in Cummingsville on South Bedford Street. This view was taken on December 26, 1898. The shop was destroyed by fire on September 5, 1900. The loss of the building and tools was $900.

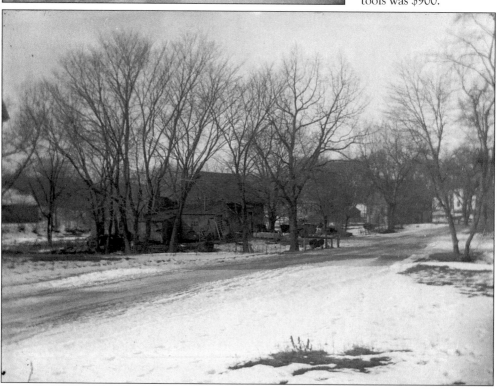

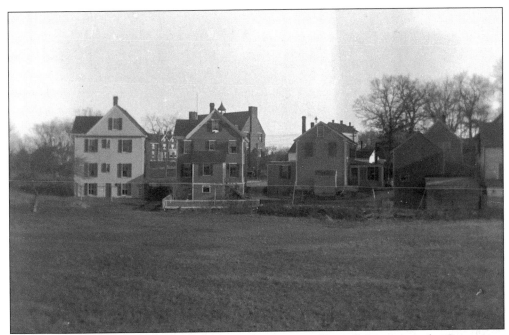

This is the site of the first tannery in Woburn, at the rear of Lowell Street near the Guastavino Tile Works. The photograph was taken *c.* 1902. The Wyman School is visible in the distance at the center.

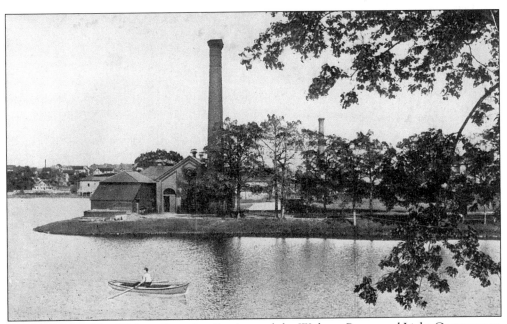

This is a view of the Woburn Pumping Station and the Woburn Power and Light Company on Lake Avenue.

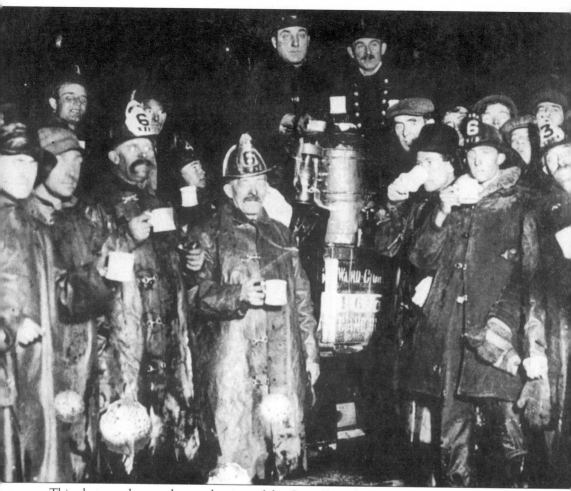

This photograph was taken at the time of the Great Fire of 1873. On March 6, 1873, all of the buildings from Walnut Street to Everett Street were totally destroyed. The fire started in the Knight Building with the explosion of a kerosene lamp in Strout's Photographic Gallery. There was difficulty in fighting the fire because the town water system was being constructed and the reservoir behind the Baptist church was frozen. Engines came from Boston, Stoneham, and Winchester. Some of the buildings destroyed included the Methodist church and the newly erected Methodist parsonage on Walnut Street. The firemen here were served coffee and rolls at 2:00 a.m. by the ladies of the Unitarian church, who were having a supper in the vestry when the fire alarm sounded. Some 25,000 square feet of area was destroyed, and damages were estimated at $75,000.

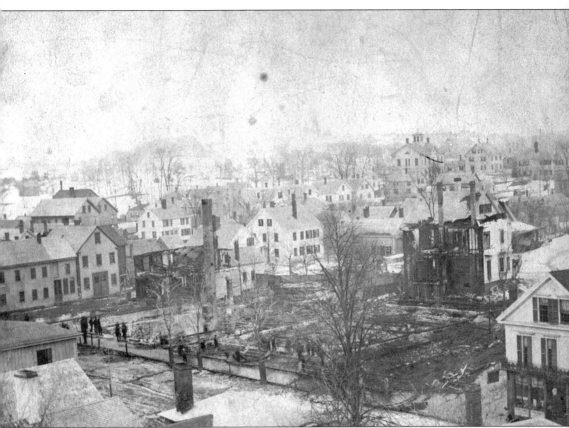

The Great Fire of 1873 destroyed the Methodist church, the parsonage, and several other buildings in the surrounding block on Main Street at the corner of Walnut Street. The Central House on the other side of the street was badly scorched. Local news reports claimed that fireman and others were in the tower of the Methodist church fighting the fire with snowballs until flames drove them from the tower.

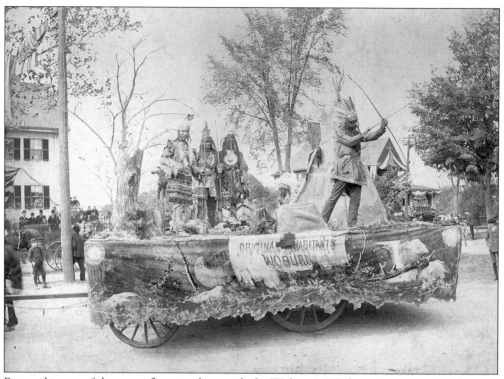

Pictured is one of the many floats in the parade for Woburn's 250th anniversary in 1892.

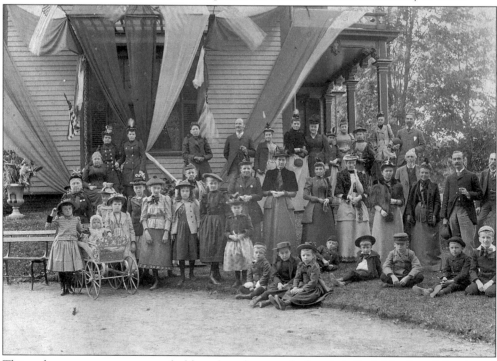

This unknown group, young and old, gathered to watch the city's festivities in celebration of the 250th anniversary, or quarter millennial.

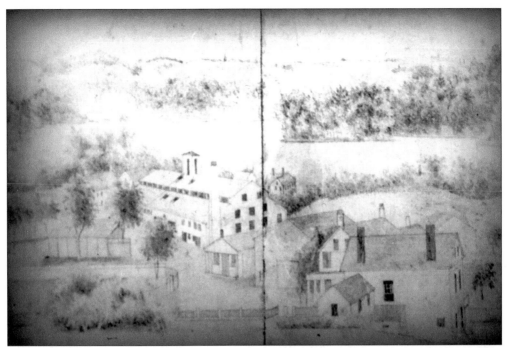

Academy House, or Academy Hall, was a house built by Thomas Henshaw before 1740. It was a private school for young ladies in 1808. The building was demolished in September 1900.

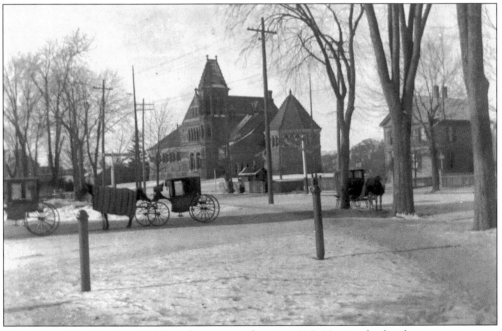

This view of the Woburn Public Library was taken in 1895. Notice the herdics or carriages in front of the railroad station. These horse-drawn cabs, named after their inventor Peter Herdic, were the taxis of their day.

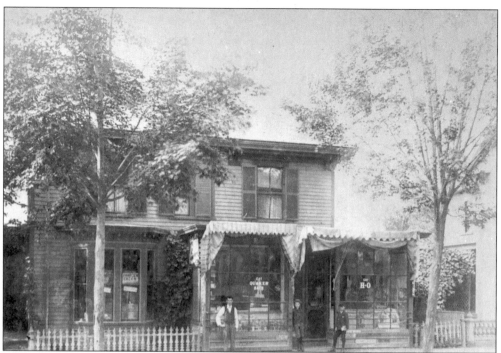

This photograph of Lee Water's store on Pleasant Street was taken in 1890. The store was located across from Reed Street.

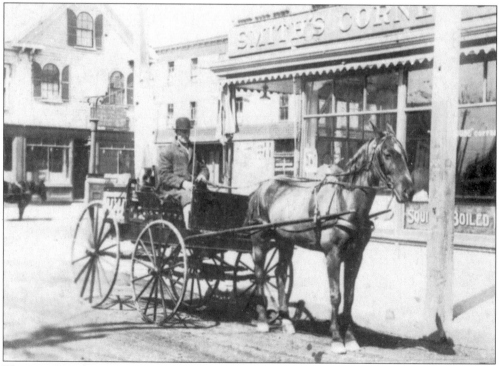

This c. 1900 photograph shows a horse and wagon outside Smith's Corner Market on the corner of Main and Salem Streets.

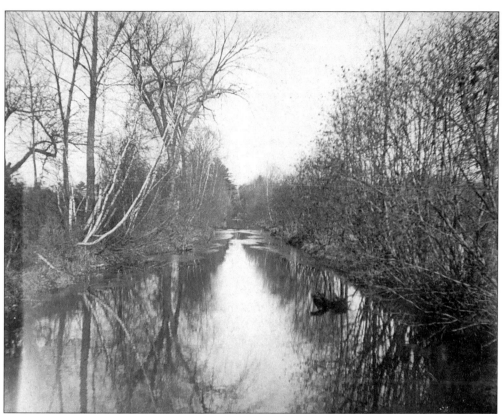

This view of the Middlesex Canal was taken on December 25, 1899, in North Woburn.

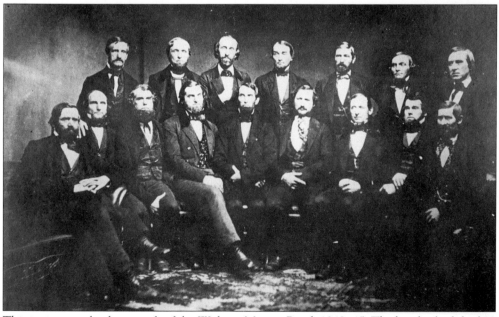

This is a very early photograph of the Woburn Marion Band, 1843–45. The band, which had 22 instruments, formed in 1842.

NAMES, AND DESCRIPTION OF STREETS,

In the Town of Woburn,

JULY 11, 1849.

MAIN STREET. From Medford line near Chas. McIntires, to Wilmington line near Mrs. M. J. Wilsons.

CAMBRIDGE ST. From West Cambridge line near Chas. Kimball's, to Burlington line near Nahum Gennison's.

WASHINGTON ST. From Main St. near N. B. Johnsons, to Reading line near Jason Rich,n's Jr.

RIVER ST. From Main St. at J. T. Langleys, to Washington St.

CROSS ST. From Main St. by Lemuel Richardsons, to Washington St.

BACK ST. From Washington St. near Samuel Richardson's, to Stoneham line near Jesse Dyke's.

RAIL-ROAD ST. From Main St., at Mrs. Ruth Leathe's, to Stoneham line near Stoneham Factory.

HILL ST. From Rail-Road St., by Ezra Hackett's to Stoneham line.

CENTRAL ST. From Wm. Beers' house, to Rail-road St. near Mr. Darracott's.

MILL ST. From Collamore's Mill, to Stoneham line (old road).

PINE ST. From Wm. Beers' to Salem St. near B. & L. Rail-road Station.

SALEM ST. From Main St. at Franklin Smith's to Stoneham line near Capt. Wm. Richardson's.

LYNN ST. From Jesse R. Fowle's house, to Stoneham line by New Road.

CEDAR ST. From Salem St., by the house of Stephen Richardson, Sr., to Stoneham line.

BOW ST. From Bartholomew Richardson's to M. J. Persons.

UNION ST. From Elbridge Trull's, to Stephen Skinners.

WALNUT ST. From the Universalist Church, to Rail-Road St.

OCKLEY ST. From Main St., by Thomas W. & Jas. N. Page's.

FIRST ST. From Horace Ward's, to Union St.

SECOND ST. From Jotham Hill's to Union St.

WILLIAM ST. From J. & J. F. Parker's, to Charles St.

CHARLES ST. From Schoolhouse near Samuel Caldwell's, to Cemetery.

NEW BOSTON ST. From Daniel Richardson's by Robert Ames', to Wilmington line near the B. & L. Rail-Road.

BEACH ST. From New Boston St., by William Jordan's, to Salem St.

MIDDLE ST. From Samuel Sawyer's by Town Farm, to Washington St.

CLINTON ST. From Main St. at S. P. Parkers by the New Road to Beach St.

ALFRED ST. From Main St. by Israel Styles', to New Boston St.

PLAIN ST. From Robert Ames' Corner, to Middle St.

SCHOOL COURT. From Main St. at Dist. No. 2, Schoolhouse, to Middlesex Canal.

MAPLE ST. From Main St. at Mrs. M. J. Wilson's, to New Boston St.

MOUNTAIN ST. From Main St. near Edward Richardson's, to Wid. Harriet Cummings'.

ELM ST. From Main St. at Wid. Bridget Jones, by the Baldwin Place, to Main St. again, near Canal Bridge.

WINTER ST. From Samuel E. Wyman's, to Wilmington line.

PEARL ST. From Burlington line near Henry Tidd's, to Burlington line again near Josiah Linscotts.

WARD ST. From Wid. Fanny Winn's, to Daniel Tidd's.

TRAVERSE ST. From Wm. Tidd's, to Marshall Tidd's 2d.

WEST ST. From Charles Thompson's, to Pearl St., by J. D. Bell's.

LOWELL ST. From Josiah Converse's by William Young's, to Burlington line.

WYMAN ST. From Col. L. Thompson's by Wm. Furness', to Burlington line.

BEDFORD ST. From George Flagg's, to Burlington line near John Cummings', Jr.

FRANKLIN ST. From Main St. opposite Dea. John Tidd's, to Middlesex Canal.

FRANKLIN AVENUE. From Franklin St., to James Cutter's house.

JOHNSON ST. From Main St. by Harris Johnson's, to Franklin St.

HOVEY ST. From Main St., to Caleb French's house.

SHORT ST. From Franklin St., to Hovey St.

PARK ST. From the First Baptist Church, to Franklin St.

PLEASANT ST. From the Common, to Tracy C. Nichols.

BURLINGTON ST. From Tracy C. Nichols', to Burlington line near Henry Cummings'.

LEXINGTON ST. From Tracy C. Nichols', to Lexington line near John Winnings' Farm.

LOCUST ST. From James Bruce's, to Joseph Steele's.

GARDEN ST. From Wm. Flagg's to Lexington St.

RUSSELL ST. From Joseph R. Kendall's corner, by Messrs. Duren's, to Lexington line.

PARKER ST. From Cambridge St. near Wid. Betsey Parker's, to Lexington St.

WATER ST. From Geo. Trull's Factory, to Thos. J. Evans'.

WARREN ST. From Pleasant St. by Warren Academy, to Main St.

CANAL ST. From Pleasant St. by Canal Locks to Main St., at Lawrence place.

COURT ST. From Pleasant St. at A. W. Manning's, to Warren Academy.

SUMMER ST. From Main St., by S. Holden's, to Warren St.

WYER'S COURT. From Summer St., to Geo. Wyer's house.

POND ST. From Main St. at Jeduthan Richaidson's, to Edmund Parker's.

CHURCH ST. From Rail Road Gate at South Woburn, by the Church, to Medford line.

MYSTIC ST. From Medford line near Mr. Smith's, to Cambridge St.

HIGH ST. From Cambridge St. near Charles Kimball's by Samuel Smith's and Ezekiel Johnson's, to Lexington St.

FRUIT ST. From Jonathan Locke's, by Asa Locke's, to West Cambridge line.

On July 11, 1849, the Town issued a listing of streets in Woburn. One of the more interesting entries describes Ward Street as running from the Widow Fanny Winn's to Daniel Tidd's.

This is a view of Hudson's Grove near Horn Pond in the late 19th century. It was located along Arlington Road.

Pictured is Shaker Glen. The Shaker religion was first preached publicly in Woburn in 1781. The Kendall family, living in an area which included this picturesque glen not far from the Winchester and Lexington lines, were the first to embrace the new religion. This antagonized their neighbors and drove the Kendalls out of Woburn. Leonard Thompson, founder of the Burbeen Lectures, coined the name Shaker Glen in 1853.

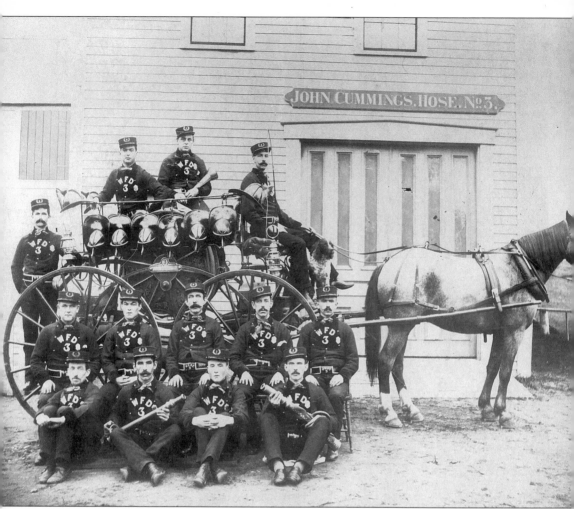

This photograph taken sometime between 1882 and 1884 shows the members of the John Cummings Hose Company No. 3 on the corner of Willow and Bedford Streets. Members are, from left to right, as follows: (front row) Dominick Folan, Thomas Ryan, Patrick Doherty, and Patrick McCafferty; (middle row) Frank M. Doherty, Philip Maguire, Lewis Breslin, Frank E. Tracy, and Neil Noon; (back row) Frank Maguire, Lieutenant Laffery, foreman John Breslin, and driver James H. Doherty.

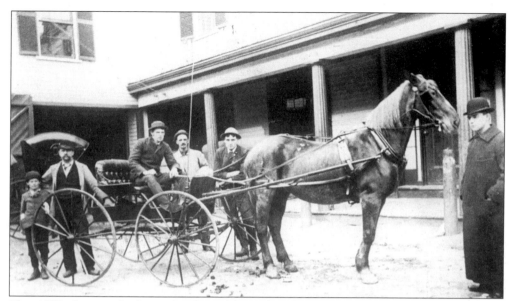

This 1895 photograph shows the the stable yard of the Central House. The Central House, opposite Everett Street, furnished a resting place and hospitality to travelers on the stage lines to Lowell.

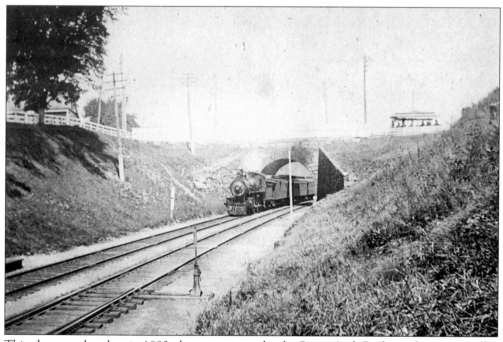

This photograph, taken in 1893, shows a train under the Stone Arch Bridge and an open trolley above the Salem Street heading for Woburn Center. The bridge was built in 1835 by J.F. Baldwin, the fourth son of Col. Loammi Baldwin. The construction was so well done that no repairs were ever necessary. Increasing traffic over Salem Street made it necessary to replace the bridge in 1929.

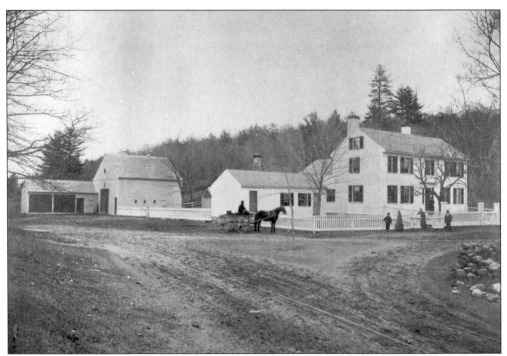

This 1866 photograph shows the home of James Otis Cummings at the corner of Winter and Mountain Streets in North Woburn. Cummings, 45, is in the carriage. He operated the tannery built in 1835 by his father, Moses Cummings. James Cummings passed away in 1906.

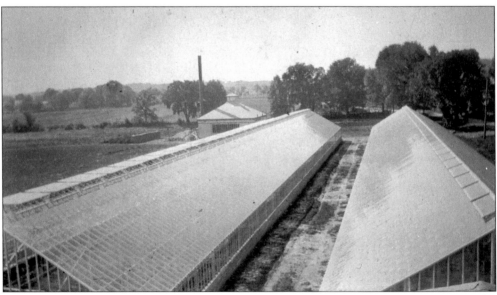

The growing of flowers eventually overtook the shoemaking and leather industries as the number one occupation in Woburn. At one time, there were over 144 greenhouses in Woburn. Woburn was call the "city under glass."

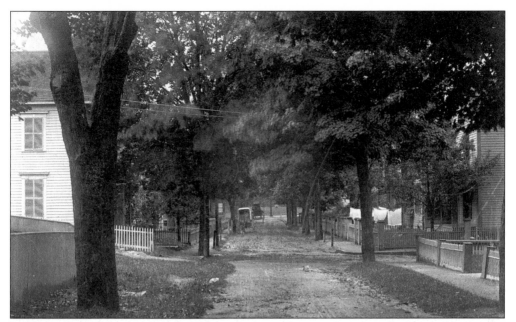

This is a view of Bennett Street looking down to Pleasant Street to the library. Notice the laundry hanging in the yard on the right and the carriage on the left.

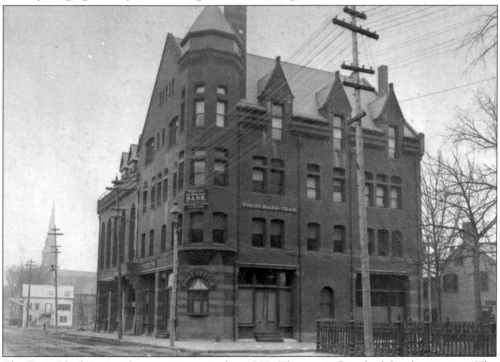

The Dow Block is seen here as it appeared c. 1890. The street floor had five large stores. The second floor had a music hall that seated 350 people. The third floor had the Mishawum Club, and the fourth floor had the Odd Fellows. The post office, the Daily Times, and the Cooperative Bank all were housed here at one time or another. The Congregational church fence is on the right. The top floors of Dow Block were removed in the 1930s.

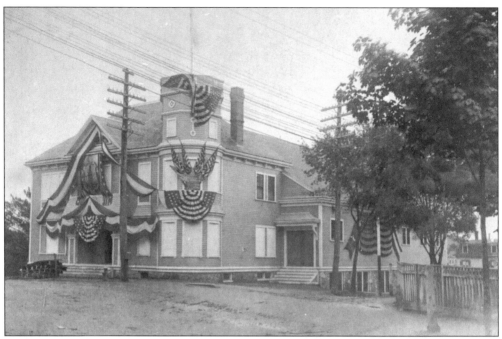

This 1892 photograph shows the armory on Montvale Avenue decorated for the city's 250th anniversary. The armory is located on the corner of Prospect Street and Montvale Avenue.

This undated photograph shows the Unitarian Sunday school class, with Alice (Champney) Wyer in the center.

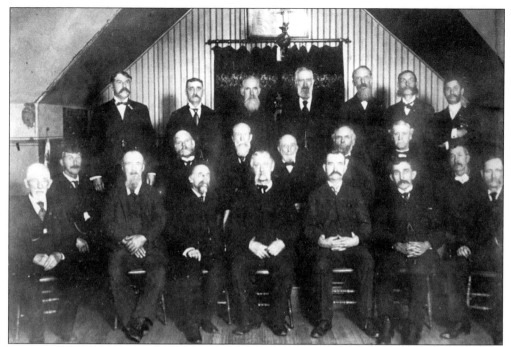

The Civil War survivors of Company K, 39th Regiment, assemble in the new Grand Army of the Republic hall in 1887. The hall was located on Pleasant Street in the Savings Bank building.

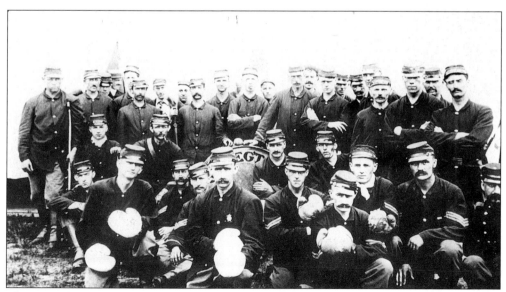

These members of Company G, 5th Regiment, are shown at camp on July 23, 1885.

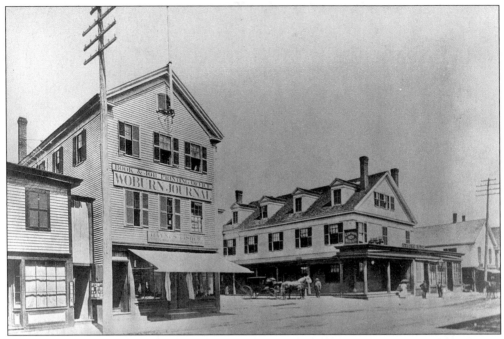

Seen here is an 1885 view of the Woburn Journal newspaper office, Haynes & Fisher Harness Makers and Carriage Trimmers, and the Central House. These buildings were located on Main Street across from Everett and Walnut Streets.

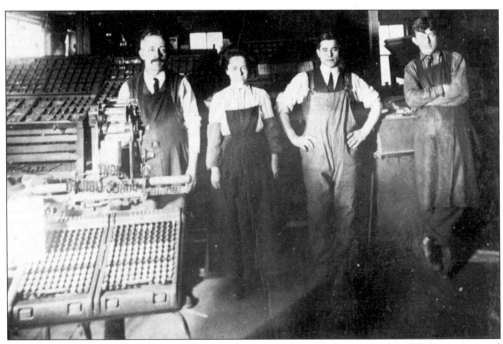

Pictured here in an undated photograph are staff members of the Woburn Journal printing office. Seen here, from left to right, are George H. Newcomb, foreman; Ella T Thorpe; Walter Hargrove; and Harry ?, the monotype operator.

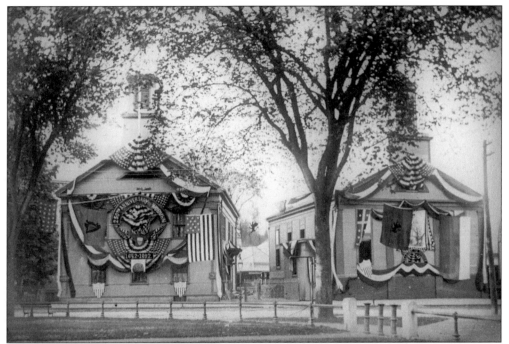

This view shows the municipal buildings on Common Street, decorated for the Woburn's 250th anniversary celebration in 1892. They were located on the present site of the city hall.

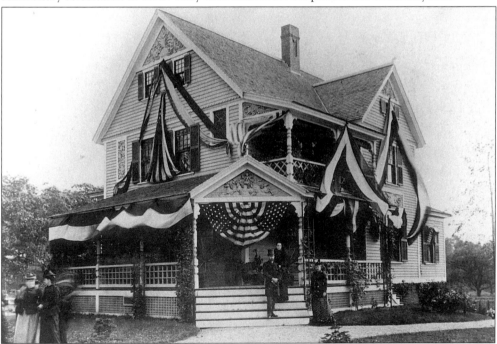

This photograph shows the Charles A. Burdett home at the corner of Mishawum Road and Main Street as in appeared in October 1892, when decorated for Woburn's quarter millennial. Mr. and Mrs. Burdett are on the steps, and Mrs. Fred H. Burdett is at the foot. Charles Burdett founded Burdett College in Boston in 1879.

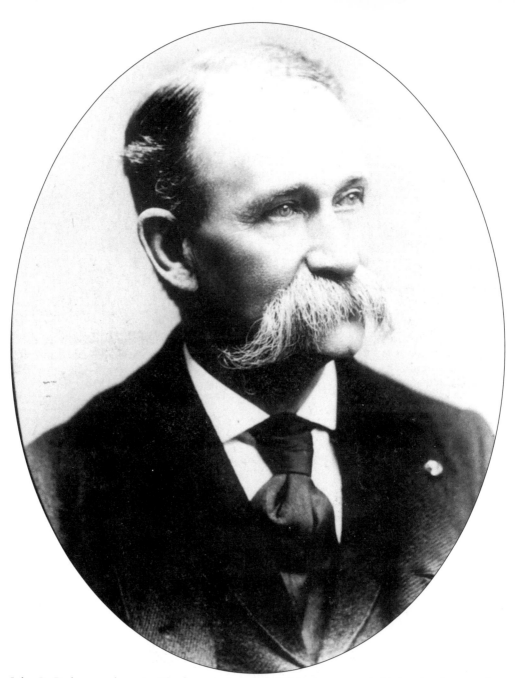

John L. Parker was born in Charlestown in 1837. When he was a child, his family moved to Woburn. He entered the printing business as a youth and after having learned the trade in Boston, he joined the staff of the *Woburn Budget*. When the Civil War broke out, he was running three newspapers, including the *Woburn Townsman*. He left the papers to enlist and gained distinction during his tours of duty. He was wounded and captured at Gaines' Mills. After the wars, he returned to Woburn and in 1868, compiled and printed the first directory of the City of Woburn. In 1880, he became editor of the *Lynn Item* and had just retired from that position when he died in 1917.

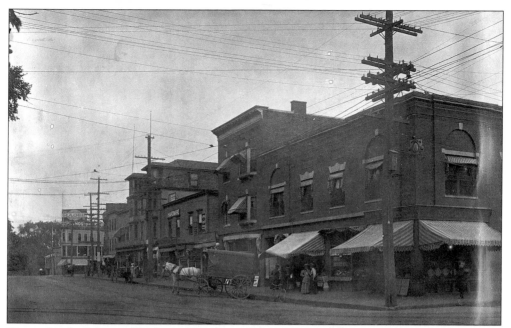

Pictured is the Johnson Block on the corner of Main Street and Montvale Avenue. It was built c. 1898 and torn down in 1938. This view was taken c. 1900. The white horse and wagon belonged to tenant David Cuneo, who was a fruit dealer.

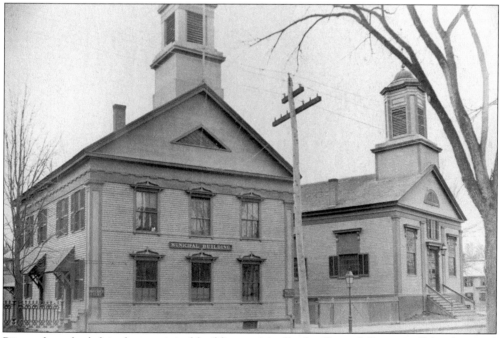

Pictured on the left is the municipal building, originally the Central Grammar School erected in the late 1840s. On the right is the Universalist church, dedicated on December 23, 1829. Later, the church building was sold to the Town, which used it first as an armory and town hall and finally as a courthouse and police station. These two buildings were in active service until 1931.

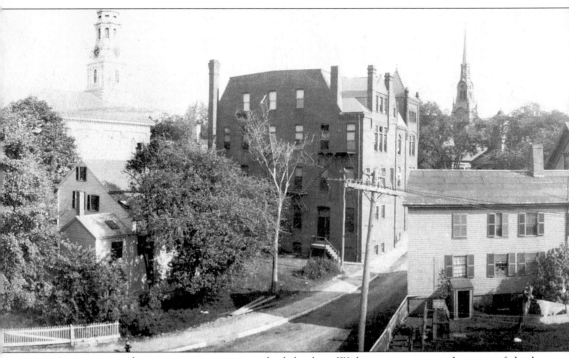

As we approach a new century, we can look back at Woburn as it was at the turn of the last century. This unusual view was taken from the roof of the new post office. All the buildings buildings between the library on the far left and the Savings Bank Building are now gone. The

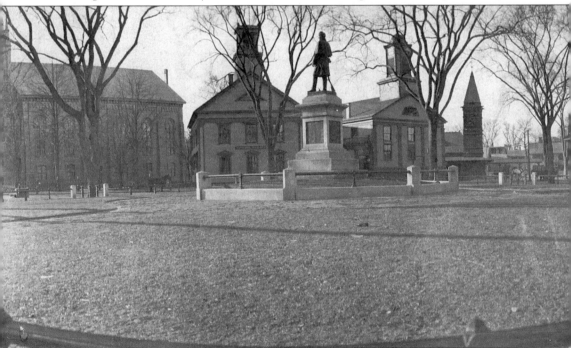

This view of Woburn Common in 1900 shows the Congregational church on the far left; the Municipal Buildings in the center background; the train station beside them; and in the

house in the center was the site of the Thomas Carter house of 1640. The rear entrance of the last leased post office is visible at the back of the Savings Bank Building.

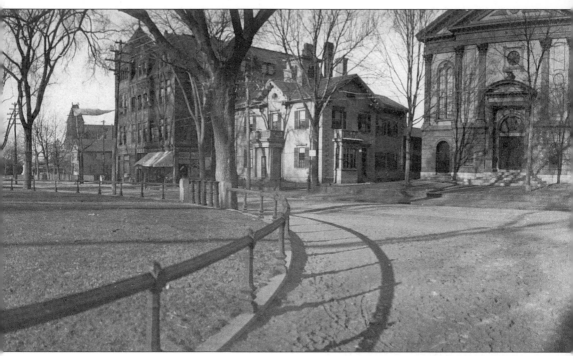

foreground on the right, the Bank Block, the Winn house, and the Unitarian church. The Soldiers Monument and the bandstand, which now has a roof, are in the middle foreground.

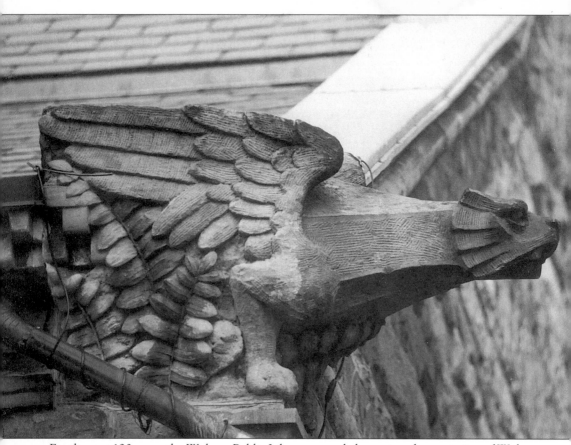

For the past 120 years, the Woburn Public Library gargoyle has enjoyed a great view of Woburn. As the new century get under way, he continues to watch over Woburn at work and at play.